W9-AAX-641

made you look

How Advertising Works and Why You Should Know

BY
Shari Graydon

ILLUSTRATIONS BY
Warren Clark

ANNICK PRESS

TORONTO + NEW YORK + VANCOUVER

Annick Press Ltd.

We acknowledge the support of the Canada Council for the Arts, the Ontario Arts Council, the Government of Ontario through the Ontario Book Publishers Tax Credit program and the Ontario Book Initiative, and the Government of Canada through the Book Publishing Industry Development Program (BPIDP) for our publishing activities.

Edited by Pam Robertson
Copy edited by Elizabeth McLean
Cover design by Irvin Cheung/iCheung Design
Interior design by Warren Clark
Indexing by Naomi Pauls

The art in this book was rendered as line drawings enhanced in Photoshop.
The text was typeset in Berkeley.

Cataloging in Publication

Graydon, Shari, 1958–
 Made you look : how advertising works and why you should know / written by Shari Graydon ; illustrated by Warren Clark.

Includes bibliographical references and index.
ISBN 1-55037-815-5(bound).—ISBN 1-55037-814-7 (pbk.)

 1. Advertising—Juvenile literature. I. Clark, Warren II. Title.
HF5829.G73 2003 659.1 C2003-900753-7

Printed and bound in Belgium.

Published in the U.S.A. by:	**Distributed in Canada by:**	**Distributed in the U.S.A. by:**
Annick Press (U.S.) Ltd.	Firefly Books Ltd.	Firefly Books (U.S.) Inc.
	3680 Victoria Park Avenue	P.O. Box 1338
	Willowdale, ON	Ellicott Station
	M2H 3K1	Buffalo, NY 14205

Visit our website at: www.annickpress.com

CONTENTS

Acknowledgments

My sincerest gratitude to Warren Clark for enlivening every page with his wonderful illustrations and design; to Pamela Robertson, Elizabeth McLean, and Barbara Pulling for providing attentive, encouraging, and creative editing advice; to Patricia Williams, for her research assistance; to Amelia Izadpanah, Clea Sackville, Jocelyn Good, Sarah Hillworth, and Sophie Ploettel for sharing their perceptions and insights with such enthusiasm; to Andrea Smith and Kamran Izadpanah for suggesting and convening the focus group; to Shailen Vallabh for asking intelligent questions about the manuscript; to Drew Kelsall for providing speedy feedback; to the staff and board members of MediaWatch for their ongoing support and encouragement; to Stephen Kline and Simon Fraser University's School of Communications for enriching my own media education; and to David Mitchell, for pretty much everything else.

AD POWER

Do you remember the day one of your parents sat you down to have a serious talk about advertising?

Me neither. And it's not something they ever test you on at school. Which is too bad, because given how easy it is to remember jingles and slogans, an ad exam might be the one test all year you wouldn't have to study for.

Really, you've been "studying" the subject almost since the day you were born: every time you got parked in front of the TV or carried past a billboard, you were absorbing the art — or some would say science — of persuasive communication.

You could say that advertising is basically anything someone does to grab your attention and hold onto it long enough to tell you how cool, fast, cheap, tasty, fun, rockin' or rad whatever they're selling is. And some people have a different definition: they argue that advertising is trickery used to shut down your brain just long enough to convince you to open your wallet!

Whichever way you look at it, though, it's so much a part of our world that trying to imagine life without it starts to sound like a science-fiction movie: *Black Holes and Other Mysteries of Life Before Advertising*. And what do you want to bet it would be in black and white?

You know that old nursery rhyme that starts, "Hot cross buns, hot cross buns, one-a-penny, two-a-penny, hot cross buns"? It started as an oral advertisement, called out by bakers in Britain, hundreds of years ago. Other peddlers selling a variety of things shouted,

"Whatchalack, Whatchalack, Whatchalack!"

These days, when many of us don't really "lack" anything, the cry is much more likely to be "Whatcha*like*."

Ancient History

In fact, advertising is even more ancient than black and white movies. It's been around in one form or another practically since people began rubbing two sticks together to make fire. Picture one caveman saying to another, "Flames. Hot flames. Yours for only one skinned rabbit."

In ancient Greece, people put up posters offering rewards for escaped slaves, merchants shouted out what they had to sell at the market, and home owners painted "For Sale" on the sides of their houses when they wanted to move.

As cities developed, merchants carved wooden signs to hang outside their shops. This is where the expression "hanging up your shingle" — meaning going into business for yourself — comes from. Since most people couldn't read, the signs used pictures, not words. You'd recognize the shoemaker's shop from the image of a boot, or the tavern from the beer mug carved into the wooden shingle.

The Printed World

Then, in the 1440s, the invention of the printing press revolutionized everything — the way people lived and worked, and the kind of information they had access to. Before the printing press, religious leaders and scholars were generally the only people who could read and write; everyone else had to rely on oral communication — speaking and listening.

But the printing press made books more affordable and gave people more opportunity to become literate. It also made it easy to produce other kinds of printed materials. As a result, handbills (imagine single-sheet brochures) and posters became the first forms of "mass media" (literally, media available to masses of people). The earliest advertisement to have survived is a handbill that was posted on the door of a London church in 1472, advertising prayer books.

The audience for such ads remained small, because many people still couldn't read. In fact, it wasn't till 200 years later that the first known newspaper ad showed up. It offered a reward for a stolen horse and must have done the trick because it was soon followed by newspaper ads for all sorts of goods, such as coffee, real estate, and medicines.

By 1758, there were so many advertisements that Samuel Johnson, a famous British writer, suggested that people had stopped paying much attention to them, forcing advertisers to make what he called "magnificent promises" — outrageous claims about what their products could do. (Two and a half centuries later, people are still complaining about advertising's tendency to exaggerate the truth.)

One of the world's best-known products started out more than a century ago as a patent medicine. In the early 1900s, its ads promised users relief from headaches and exhaustion. Today, its claim — to quench your thirst — is more modest. But its name — Coca-Cola — has remained the same.

"Patent medicines" came to be seen as the biggest offenders. For one thing, they were rarely real medicine, and for another, their creators didn't usually even bother registering these so-called "miracle cures" with the patent office, which was responsible for recording who invented what.

Take Lydia Pinkham's Vegetable Compound, for instance. It promised a "Positive Cure for All Female Complaints," and was very successful — at convincing people to buy, as opposed to curing all complaints. Another product, called Keller's Roman Liniment, made even more exaggerated claims, bragging that Julius Caesar had used the lotion centuries before to conquer the world. Not believing the ads, people didn't buy the product. But the makers of the lotion didn't give up; they just changed the strategy. And after renaming the product "St. Jacob's Oil" and claiming that it was made by monks in Germany's Black Forest, it sold very well!

I can advertise dishwater and sell it... It's all in the advertising.

—a patent medicine salesman

Creating Consumers

By the early 1800s, the industrial revolution had introduced machine power to manufacturing in Europe and North America. This allowed companies to produce many more goods at a much faster rate. Suddenly, things that people were used to having to make themselves — like soap and candles — were now cheaper to buy than to make at home.

You might think that families would have been happy to give up the time-consuming process of churning butter or gathering beeswax. But they weren't used to buying things. They had to be persuaded to stop being so self-sufficient. They had to be convinced to start spending their money on products that companies were making for them.

That's when advertising really jumped into high gear. Its job became not only to get people to buy, but to convince them to think of themselves differently — as consumers. At the time, this was a radical idea. People tended to define themselves by what they did, or made. If they were competitive with their neighbors, it wasn't about who had the newest car or the biggest TV. It was much more about baking a tastier loaf of bread or being more skilled with a handsaw. Folks who had to buy their goods from someone else might actually be considered incompetent!

Advertising had to work hard to change that attitude, to persuade people that factory-made — as opposed to homemade — things were better. One of the ways advertisers did this was to put logos on their packages. Campbell's Soups and Quaker Oats were among the first to do this in the 1880s. The logos were designed to make mass-produced goods seem more familiar or personal. Characters — like the man who still appears as part of the Quaker Oats logo — were created to make people feel as if they were buying from a trusted shopkeeper.

A logo is a company's identifying "signature." It can be simply the company's name, written in a special style (like Coca-Cola's logo, for instance); it can be a symbol (like Nike's "swoosh"); or it can be another kind of image (like the drawing of an arm and a hammer on Arm and Hammer baking soda boxes).

New Media

If the printing press revolutionized advertising, new developments in technology have continued to spawn new forms and give life to old ones. When photography was introduced in 1839, advertisers were able to show images of real people, products, and places, instead of the drawings that had been used before. Promotions for ready-made clothing, cast-iron stoves, and bicycles could all be captured on film, instead of by an artist. Then rail transportation sped up postal service, which increased companies' use of magazine advertisements and other stuff they could send by post — leading, no doubt, to the first-ever complaints about junk mail!

The amount of advertising grew very quickly. By the 1850s, streets in London, England were so crowded with wooden carts carrying ads as opposed to people that the city passed a law restricting their number. And by the end of the century, many daily newspapers had grown to more than 100 pages, and were half-filled with advertisements.

Yet when radio was first introduced, many people resisted the idea that commercials should be allowed on the air waves. In 1922, for example, a senior US government official said it was unthinkable that radio should be "drowned in advertising chatter."

Advertisers themselves weren't immediately enthusiastic either. But as radio became more popular, they became more interested. In fact, the term "soap opera" was coined in the early days of radio when soap companies "sponsored" radio dramas. This meant that rather than simply promoting their product in a 15- or 30-second commercial, the companies and their ad agencies actually wrote the scripts, hired the actors, and produced the plays — working in mention of their products in the process.

Still, only a few kinds of products were advertised on radio. In addition to soap, these included drugs (such as headache pills), tobacco, and food items.

Television, which was first broadcast in North America in 1939, adopted an approach similar to radio at first. The programs were named after their sponsors, resulting in *Kraft Television Theater* and *Goodyear TV Playhouse*.

But by the 1950s, broadcasters began to seek more control over what was being shown on their channels. Advertisers weren't eager to give up their half-hour commercials in exchange for one-minute spots, but the cost of producing television programs was increasing, making it more difficult for a single advertiser to foot the bill. When some popular game shows were exposed as being rigged and unfair, it helped to shift more responsibility for programming control over to the companies that owned the stations, as opposed to the companies selling products.

The game show scandal was big news at the time (and many years later it inspired a movie called *Quiz Show*). As a result, many people became very skeptical about TV, and stopped believing it was a source of truthful information. As well, advertisers were forced to give up control of the programs, and instead had to buy the kind of commercial spots that are common today.

In the past 10 to 15 years, advertisers have had a new means of reaching the people they want to influence: the Internet. Because the Internet is so different from television or radio, they're still experimenting to find the most effective way to promote their products and services. Some use banner ads at the top of popular websites; others create their own flashy and interactive sites in the hopes of attracting Internet surfers to visit and buy on-line.

Communications technology continues to evolve. DVD players are replacing VCRs, video games are becoming more realistic all the time, and interactive TV is about to change how we watch television. Can you imagine what other options there might be 10 or 15 years from now?

Ads Unlimited

People in Ghana, a country in West Africa, have a saying: *To the fish, the water is invisible.* In other words, when you're surrounded by something all the time, you don't notice it. You take it for granted and assume that it's natural, or that it's always been there. You don't think about whether it's good or bad, or how it's affecting your life.

In parts of the world where people have a lot of modern conveniences and up-to-date technology, you could say that advertising has become "the water in which we swim." There's so much of it that we hardly notice it anymore. In fact, some experts estimate that a young person growing up in North America is likely to see between 20,000 and 40,000 TV commercials every year. When you add in all the advertisements from other media — up to 16,000 a day! — it's easy to see how you'd begin to stop noticing, and just keep swimming.

It's Everywhere! Throughout this book, the bug-eyed fish icon, representing the inescapability of advertising, signals new (but not necessarily improved!) locations for advertising that have cropped up just in the past few years. Big stickers on supermarket floors promoting grocery items, for instance, are a recent invention. So are city buses that have been painted from top to bottom and front to back with advertisers' sales pitches.

DON'T Try This at Home!

The mind boggles trying to imagine 16,000 ads in a single day. But what if you tested the estimate? What if, from the time you got up one morning, till the time you went to bed that night, you counted every single commercial message that showed up in your surroundings?

If you try this, don't forget to include: fridge magnets, radio jingles, promotional messages on your morning cereal box, the neon and awning signs of local stores, posters on telephone poles, outdoor billboards, bumper stickers, ads on city buses, photos on pop machines, posters in school hallways, logos on your friends' clothing, blurbs on your favorite Internet sites, ads in magazines — not to mention commercials on television!

> Advertising is the rattling of a stick inside a swill bucket.
> —George Orwell, British writer

For those of you who've never lived on a farm, a "swill bucket" is the bucket used to feed pigs. And the rattling stick is designed to tell the pig it's dinnertime. It's kind of like when stores blast rap music out onto the street — because we see so many advertisements every day, in so many different places, advertisers have to try harder and harder to get our attention…They have to "rattle their sticks" more and more loudly, and constantly come up with new ways to convince us to come running when they call.

Ad Impact: Candy or Vitamins?

Are sugared breakfast foods a subject of debate in your house? Do you beg for Alpha-bits cereal, while your dad insists on Shredded Wheat cereal? My mom called the heavily promoted sugary stuff "candy — with no redeeming food value," but I always argued it was nutritious, and pointed to the vitamin chart on the back of the box. Was one of us right, or was it just two ways of looking at the same thing?

The debate about the impact of advertising is also a hotly contested one, and not so easily resolved as a tug-of-war over cereal boxes. Let's look at the two sides.

Advertisers Say:	Critics Say:
◆ advertising helps to sell more products, allowing companies to make many items at once, and to do so at a lower cost; it also lets people compare prices, and find the least expensive product; this competition keeps prices low	◆ the money spent on advertising makes products more expensive; consumers are ultimately the ones who pay for advertising through higher product prices
◆ advertising protects consumers by informing them — and because companies that spend a lot of money promoting their product work harder to keep their promises and ensure the product is worth buying	◆ advertising makes it easy for big companies (with lots of money to spend on promotion) to put small companies (which can't afford to advertise as much) out of business and limit competition
◆ advertising gives consumers many products to choose from and by encouraging people to buy, it keeps money circulating and people employed	◆ by encouraging people to buy things they don't need, advertising contributes to waste, creating pollution and damaging our environment
◆ advertising promotes products that can improve people's lives; it encourages them to strive for a better life	◆ advertising tends to show only certain kinds of people and to define beauty in a narrow way; it encourages people to be dissatisfied with themselves, to feel insecure and vulnerable
◆ advertisers sponsor many sporting and cultural events (tennis tournaments, professional car races, musical concerts, fireworks displays); their support provides entertainment that wouldn't be possible if it relied only on ticket sales	◆ advertising messages sometimes contradict the values of the events being sponsored (driving a car and drinking beer isn't a good combo; cigarette addiction makes it harder to be a good athlete)
◆ advertising can be used to promote important social messages (to encourage people to fight racism, or donate to charity, or exercise for good health); it can be a critical public safety tool in emergency situations (recalling a faulty and dangerous product, for instance)	◆ advertising encourages people to engage in activities that are unhealthy or dangerous (like eating junk food or driving too fast); the lifestyles promoted may collide with or distract from such values as building caring relationships, or environmental responsibility

The pro-advertising folks say that people make rational decisions about what they're going to buy — that consumers consciously think about their choices and make decisions using their minds. Others argue that a lot of advertising is designed to engage people's hearts, not their minds. They suggest that ads affect us emotionally, not rationally, and trick us into buying products for the wrong reasons.

Advertising makes you spend money you don't have for something you don't want.

—Will Rogers, American actor

Advertising nourishes the consuming power of men. It sets up... the goal of a better home, better clothing, better food... It spurs individual exertion and greater production.

—Sir Winston Churchill, British prime minister

DON'T Try This at Home!

What do you think? Are you on Will Rogers' team, or do you think Winston Churchill had it right? Maybe there's truth on both sides. Think about how advertising impacts your life:

- What forms of advertising do you notice the most?
- What kinds of advertising do you enjoy?
- Have you ever felt interrupted or annoyed by advertising? Why?
- Can you think of an ad that made you want to run out and buy the product? What was it that convinced you?
- Do the ads you see give you facts about the product, or appeal more to your emotions?
- If you hear or see things in an advertisement that you don't believe or agree with, how do you react?
- Have you ever bought something solely as a result of seeing it advertised? Did the product live up to the advertising message?

Who Knew? Clever Campaigns Create New Needs

Do you know how diamonds came to be the gem of choice for engagement rings? You might imagine that it's a centuries-old tradition handed down for generations. In fact, diamond engagement rings are an invention of advertising. For centuries, opals, rubies, and sapphires were considered much more exotic than diamonds, and more often featured in women's engagement rings. But in 1947, the big diamond producer De Beers began advertising the glittering white stones as the embodiment of love.

The company's slogan, "Diamonds are forever," cleverly equated the hardness and durability of diamonds with the notion of permanent love, and diamonds quickly became synonymous with engagement rings. Isn't it strange that a few words, repeated many times, can change how people think and act?

Brain Stain

Here's that quiz you might not have to study for: it tests your knowledge of famous advertising slogans. Cover up the right-hand column below and see how many of the following are familiar to you. Some of the ads aren't around anymore, or weren't aimed at kids in the first place, but chances are you may have heard them anyway — which tells you how powerful advertising can be. Try testing your friends or family members: see if they can identify the products these slogans tried to sell, or hum the musical jingles that belong to some of the phrases.

	Slogan	Company/Product
1	Just do it.	(Nike shoes)
2	Mm, mm, good. Mm, mm good.	(Campbell's soup)
3	They're GRRRRRRRRREAT!	(Kellogg's Frosted Flakes cereal)
4	Live in Your World. Play in Ours.	(Sony PlayStation system)
5	There's a little _____ in everyone.	(McDonald's foods)
6	Oh I wish I were an _____ wiener, that is what I'd truly love to be.	(Oscar Mayer wieners)
7	Snap, crackle, pop.	(Kellogg's Rice Krispies cereal)
8	Is *It* In You?	(Gatorade drink)
9	Finger lickin' good.	(Kentucky Fried Chicken pieces)
10	Have a break.	(KitKat candy bars)
11	Maybe she's born with it, maybe it's...	(Maybelline cosmetics)
12	They're magically delicious.	(Lucky Charms cereal)

Lots of people, when asked, say that advertising doesn't affect them. Next time you hear someone make that claim, test them to see how well they do on the quiz above.

What, Me?
A Walking Billboard?

Every time you put on a T-shirt or a pair of jeans sporting a company's logo, you become a walking billboard, "advertising" the company's products.

DON'T Try This at Home!

Check your clothes closet to find out how much free publicity you're giving to Nike, Adidas, or The Gap. Think about the exchange: you get a T-shirt; the company gets the money you paid for the shirt plus the profile and exposure that comes from you wearing it.

Your willingness to sport the company's name on your body is the same as you personally endorsing the product and its makers.

Also, think about how some fashion trends support the goals of advertisers. When kids started to wear their pants so low that the tops of their underwear showed, which clothing manufacturers got more "exposure"?

Movie Product Wars: The Merchandising Menace

Once upon a time, movies were movies, toys were toys, and fast-food restaurants had nothing to do with either. Then *Star Wars* came along (the first one came out way back in 1977), and things haven't been the same since.

George Lucas, creator of the *Star Wars* series, was the first person to turn the launch of a new movie into an advertising extravaganza. In addition to the millions of dollars spent making the film — creating those awesome special effects, for instance — Lucas spent additional millions promoting it. And not just through movie previews, TV ads or in newspapers. He also made special deals with all sorts of companies to produce *Star Wars* toys, clothes, and give-away collectors' items.

This kind of advertising approach is called "cross-promotion," because it works two ways: people see a Harry Potter movie and are then more likely to want to buy wizard merchandise or the books; or they have always collected Pokemon cards, so they go to see the *Pokemon* movie when it comes out.

What does this add up to? The first *Star Wars* movie was one of the most popular of all time, earning millions of dollars, and ensuring that the next two episodes would also attract a lot of viewers. But that was peanuts compared to the

product sales. Together, the first three *Star Wars* installments made 4.5 BILLION dollars through the sale of character toys, posters, video games, laser swords, and a whole lot of other stuff. (For perspective, with that kind of money you could buy yourself and five friends a brand-new $30,000 car every day for the rest of your life, assuming you lived another 70 years!)

The demand was so high that at one point, toymaker Kenner couldn't keep up with the demand for Hans Solo and Luke Skywalker action figures, and had to send customers empty boxes with "I.O.U." slips in them. In fact, the *Star Wars* trilogy was so successful that the producers came up with a new way to take advantage of its popularity. After the sequels, they have moved on to creating "prequels," including *Episode II: Attack of the Clones*, and benefit from cross-promotion opportunities for new characters like the young Anakin Skywalker and Jar Jar Binks.

Many other movies have followed in *Star Wars*' footsteps since, from *Jurassic Park* to *Spider-man*, from *The Lion King* to the *Lord of the Rings* trilogy. Nowadays, you don't even have to go looking for the movie to know what it's about: the advertising — in all its forms — will find you first!

Did you know that when people first started going to the cinema, both film trailers and regular commercials shown before the movies were unheard of? Not only that, they were unwelcome! In the 1980s when commercials first started to be shown in theaters, some people were so outraged they stood up and started shouting,

"Hey! I've already paid my $5!"

Space Jam is a merchandising bonanza first and a movie second. The idea is to sell lots of product.

—Jim Riswold, Nike advertising executive

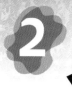

YOU'RE IT!

You're the Bull's-eye

Once upon a time, advertisers didn't pay much attention to kids. They aimed all their sales pitches at adults.

But things have certainly changed. Starting in the 1950s, advertisers began to realize that kids not only had money of their own to spend, but they also influenced a lot of their parents' shopping decisions.

Imagine a dartboard with a picture of you and your friends in the center of the board. You're now an important "target," and many advertisers think about *your* interests when designing their products and ads. In fact, advertisers in North America spend more than $2 billion a year trying to convince you to spend your money — or your parents' money! — on the stuff they're selling.

How can they afford to do this? Because the dollars they invest in advertising amount to a drop in the ocean compared to the dollars they get back when you respond to their sales pitches. In fact, some marketers estimate that kids in North America spend more than $100 billion every year on clothes, candy, games, videos, music, movies, and food.

And then there's what advertisers call the "nag factor": they deliberately try to dream up ads that will help you to convince your parents to buy one kind of pizza instead of another, or rent this movie over that one. They conduct research to find out what kinds of commercials are the most effective — for example, which jingle or special meal deal is most likely to help you drag your mom or dad to the fast-food restaurant.

They also know that kids influence adults' decisions about much more expensive items, like computer equipment and family vacations. Car manufacturers have a name for this: they refer to 8- to 14-year-olds as "back-seat customers," recognizing that kids may even cast the deciding vote about which car their parents should buy. In fact, one kids' magazine — meant to be read by people too young to have their own driver's licence — carried ads for minivans!

Some marketers estimate that kids have a say in close to $300 billion worth of their parents' spending. So some advertisers target *you* in order to get to adults.

Research also tells advertisers that if they hook you when you're young, chances are better that you'll keep buying their products as you get older. This is called "brand loyalty." Shopping experts have figured out that a customer who regularly buys from the same store, from childhood until she dies, is worth as much as $100,000 to the store. So advertisers try to come up with what they call "cradle to grave" marketing strategies that will help them turn you into lifetime customers.

One roadside ice cream stand in Pennsylvania took advantage of the "nag factor" by putting up a sign that said: "Scream Until Dad Stops."

If you own this child at an early age, you can own this child for years to come.
—Mike Searles, president of the marketing company Kids 'R Us

Which Came First — The Programs or the Ads?

That age-old question about which came first, the chicken or the egg, is a little easier to solve when applied to advertising. But the answer might surprise you.

When we turn on the radio to listen to music, or switch on the TV to watch our favorite shows, we think of the commercials as interrupting the songs or programs. But from the advertisers' perspective, the music, movies, comedies, and news are only there so that people will tune in and be listening or watching when the advertising comes on!

Companies with things to advertise buy "airtime" on specific shows. The money they pay for the airtime is used by stations and production companies to produce the programs. Television shows especially are very expensive to make. The writers, directors, actors, and camera operators all have to be paid. The money that radio and TV stations get from soft drink, food, and clothing advertisers pays for salaries and buys costumes, sets, special effects, and much more.

Only a few publicly owned stations—like PBS or National Public Radio in the US, or CBC Radio in Canada—rely on government or viewer funding for most of their programming.

Advertising executives like to say that television shows are the meat in a commercial sandwich.
—Todd Gitlin, author and media critic

We're here to serve advertisers. That's our reason for being.
—CBS TV executive

Here's another way to think about media and advertising. Imagine a mousetrap set up with a piece of cheese. The TV ads are the trap, the programs are the cheese, and you are the mouse. The cheese is what the advertisers use to lure you, the mouse, into the "trap" of watching their ads. (Fortunately, watching TV—or listening to the radio, or reading a magazine or newspaper—won't kill you the way a mousetrap does a mouse!)

Depending on the kind of product they're selling, TV advertisers will use different kinds of "cheese" (or programs) to entice the right kind of "mice" (or audience members). Essentially, they're looking for shows that have proven to be popular with the kind of people who buy their products.

Consider the chart below. It gets you thinking about how advertisers target their ads to the people most likely to want what they're selling, and how they use certain kinds of programs or articles to attract those people to their ads. Knowing one part of the advertiser/mouse/cheese equation, you can often guess the other two parts.

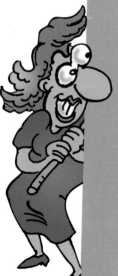

Advertiser/Product	TV Show	Audience
hair care products	soap operas	women and girls
stuffed toys and games	cartoons	small children
beer	football	men
retirement services	news, movies	grandparents
fast food	comedies	kids, teenagers

Who's the Product?

Let's say Marvin Bigwig, owner of Everybody's Favorite Television (EFTV for short) has a show on his station called *Rad,* about a bunch of kids who have superhuman powers whenever they eat junk food. The show has great special effects and awesome music, and it airs every weekday afternoon at four o'clock — after school, but before dinner, when you're bound to be hungry!

Marvin Bigwig goes to advertisers and says, "Kids love this show. They love it so much that *I can promise to get you the attention of millions and millions of them every day.*"

The advertisers — especially the ones selling pop, potato chips, ice cream, and candy — say "Okay! We'll give you money to broadcast our commercials on your show so we can sell our snack food to these kids."

Marvin Bigwig has actually "sold" *you* and *your attention* to the advertisers.

This makes you not just the mouse, but — at the same time — the product used to catch advertisers!

Advertising to Advertisers

Your role as "the product" is really clear when you check out the kinds of ads that media companies themselves use to attract advertisers to their channels or publications. A TV sports network promoting its air-time to potential advertisers promised: "We deliver the male." In other words, male sports fans are the "product" that the sports network is "selling" to other advertisers.

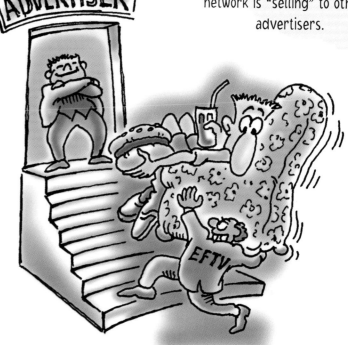

FAST Food

Kids in North America see more than 10,000 commercials for food on TV each year. And most of those — more than 90 percent — are for soft drinks, candy, fast food, and sugar-coated cereal. Your mouth is probably watering already...

Unfortunately, these are exactly the kinds of foods that doctors and dietitians encourage people to avoid. They're among the foods most likely to make you fat. And more and more kids today (about one in five) are wrestling with a weight problem — from both fast food and lack of exercise. No surprise: sitting in front of the TV or computer doesn't burn nearly as many calories as playing outside. In fact, recent studies have shown that the more time kids spend watching TV, the more weight they gain. The good news is that when kids stop spending so much time with TV or video games, they can lose weight!

Advertising's not entirely to blame for this, of course. But you don't have to be Einstein to figure out that fast-food promotions have an impact.

NOW DON'T EAT TOO MUCH SWEETIE...

Internet Cheese

TV programs aren't the only kind of "cheese" used by advertisers to get your attention. Because kids today spend a lot of time on computers surfing the Internet, more and more advertisers are figuring out new ways to attract you to their promotional messages. Some companies with products to sell to kids develop cool websites, with lots of interactive games, contests, and free software. It's like they've created an on-line playground that gives you interesting stuff to do and download. But unlike on TV, it's rarely clear where the entertainment stops and the commercials begin.

Movie companies in particular have been really smart about getting kids to visit their sites and help them build hype for soon-to-be-released movies. By providing trailers that can be downloaded and forwarded electronically, the companies are turning "word-of-mouth" advertising into "power-of-email" promotion that kids do for them with the click of a mouse.

While you're on their websites, many companies ask you to fill out a questionnaire or give them feedback. They want to find out as much as they can about you and your family. The more they know about what you like to do and buy and watch, and how much money you have, the better they think they'll be at persuading you to spend it on their products.

And when you're "swimming" around the Internet, getting caught up in games or contests, research shows that you can easily slip into what is called a "flow state." Your heightened excitement makes you less likely to question, and more likely to respond to advertiser suggestion. (Which gives the expression "go with the flow" a whole new meaning!)

Surfer Beware

For safety and security reasons, you probably know that it's not usually a good idea to be giving out personal information over the Internet — to advertisers or anyone else. That advice you've heard about not talking to strangers applies as much on-line as it does on street corners. Not all the sharks in the world are found at the beach!

It's Everywhere!

It's getting harder and harder for advertisers to stand out and as a result they're getting more and more creative about where they place their ads.

Think about how you watch TV or listen to the radio, for instance. You might be hanging out with your friends, riding in a car, eating breakfast with your family. Under those circumstances, there might be lots of other things to distract you so that you don't pay attention to the TV commercials or radio jingles.

In the past few years, advertisers have found ways to get around such distractions. Some have even put up ads in public washroom stalls! If you're sitting in a bathroom cubicle or standing at a urinal in the school washroom or a movie theater, you're pretty much a "captive audience" — there's nowhere else for you to look but at the ad.

"For You, Not *Them*"

Advertisers think a lot about exactly what they should say in their ads to persuade you to part with your allowance. For instance, they know that when adults disapprove of a certain kind of activity (such as staying up late, or substituting junk food for veggies), the activity often becomes even more appealing to kids. One bubble gum company made this the focus of its advertising campaign. The commercials showed math teachers and parents saying things like, "I can't *stand* Bubble Tape." And the tag line for the ad was, "Bubble Tape— for you, not *them*."

Advertisers know that kids are constantly being told what to do — by their parents, their teachers, their coaches. So some of them try to feature kids who are on their own, in control, and not having to answer to adults. They look for ways to make you feel they're your friend and ally, and that they feel the same way about things as you do.

But no matter how cool or fun or sympathetic advertisers appear to be to you and the things you care about, it's important to remember that ultimately what *they* care about is your money.

How do adults think they can save the world? They can't even play Nintendo.
—line from a Nintendo ad

Advertising School

Is your school one of the more than 12,000 across the United States to subscribe to Channel One, or in Canada, YNN (The Youth News Network)? This specialty TV service was created to help advertisers reach kids right in the classroom.

The people behind Channel One and YNN recognized that many schools have to fund-raise to buy textbooks and electronic equipment, and figured that schools might welcome free televisions and VCRs. So they offered schools the equipment in exchange for the eyes and ears of kids like you. "We'll give you all this stuff," they said to school boards, "plus a daily newscast designed especially for students, if you make sure they sit still and watch the broadcast every day." (As if convincing kids to watch TV in school would be difficult!)

How can Channel One and YNN afford to produce newscasts and buy equipment for thousands of schools? You guessed it — once again the magic word is advertising. In fact, advertisers whose commercials appear on Channel One and YNN pay the specialty station twice as much as they would for the same ads appearing on a regular network that you get at home. Why? Because just like when you're in the washroom stalls, they know you're a captive audience.

The biggest selling point to advertisers is forcing kids to watch two minutes of commercials... The advertiser gets a group of kids who cannot go to the bathroom, who cannot change the station, who cannot listen to their mother yell in the background, who cannot be playing Nintendo...

—Joel Babbit, the former president of Channel One

Channel One and YNN schools have to:

- make you watch the ads;
- stop you from channel surfing;
- keep the volume turned up.

Ever since the programs started in the early 1990s, the presence of advertising in schools has been a topic of hot debate. Although schools are able to use the electronic equipment for many other things besides watching the supplied newscasts and commercials, not everyone agrees that the more than 8 million students who are forced to tune in really benefit from the deal.

Here's how the debate shakes down:

Channel One and YNN Say:	Some Educators Say:
◆ TV is a good way to teach kids about current events because they're more interested in moving images than words on a page	◆ the news items are too short to really teach kids anything and the stories often don't have much to do with what students need to know
◆ newscasts designed especially for kids will be easy for them to understand and help them to become interested in current evnts	◆ research shows that kids' knowledge of current events didn't improve when they watched Ch. 1/YNN; 24 hours after the show, most kids couldn't recall the news items or their importance (but they did remember the ads!)
◆ since schools are short of money, and advertisers are willing to contribute by helping to pay for much-needed equipment, everybody wins	◆ schools are funded by the government, and paid for by everybody through taxes, so the time that kids spend watching Ch. 1/YNN actually costs us all, because it's time during which they aren't learning useful things
◆ teachers and students can use the equipment for other purposes, such as viewing other TV programs and videos	◆ schools in poor neighborhoods, where students are already at a disadvantage, are even more likely to sign up with Ch.1/YNN, meaning more poor students are exposed to such ads than other kids
◆ since kids are exposed to advertising everywhere else anyway, what difference does it make if they see it in school, too?	◆ kids are already bombarded by commercial messages in the rest of their lives; schools should be advertising-free zones so they can focus on learning

Exposing kids to commercial messages in school is not actually a new idea, and it's not restricted to specialty TV services. Way back in the 1920s, toothbrush companies invited themselves into classrooms, putting students through "toothpaste drills." Makers of cocoa powder also visited science classes to demonstrate how cocoa was produced. Their intent was to attract consumers as well as to educate.

Today, many schools let advertisers promote their products on school property in exchange for financial support. Soft-drink companies, for instance, give schools cash and vending machines and in return, the schools give the companies "exclusive rights," meaning that no competing drinks can be sold on school property.

A few years ago, a high school in Evans, Georgia made this kind of deal with Coca-Cola, which sponsored a special "Coke Day" throughout the school. But when a student showed up wearing a T-shirt with Pepsi's logo on it, he was suspended. That got people talking!

Some people think that exclusive deals with one advertiser that disallow other advertisers are unfair. They say advertising is supposed to give people choices about which products they buy. Allowing one advertiser sole access to the school eliminates choice.

What Do You Think?

Should advertisers be allowed into schools? Does it make a difference to you if schools accept money for such things as computers or sports equipment in exchange for putting company logos on team uniforms, wrapping textbooks in promotional messages, or naming food items in the cafeteria after characters in their movies? Is it okay for schools to promise "exclusive rights," or is getting to choose between different products important to you? Or do you side with the people who believe school should be an advertising-free zone?

Not Me!

While most of us deny that we're affected by advertising, we're usually willing to admit that it probably has an impact on others. Researchers call this the "third-person effect." They say that none of us thinks of ourselves as being so easy to persuade — even though we realize that the sheer volume of commercial messages must have an influence on somebody.

The fact is, sometimes advertising works and sometimes it doesn't. And not everyone is affected the same way, or by the same campaigns. What you like to do, how you feel about certain things, where your family is from, and what kinds of things are important to you all influence whether a particular ad will make you want to buy a product, or just throw a book at the TV.

But younger kids are especially likely to respond to commercials. One study found that more than 90 percent of preschoolers ask their parents for toys or food they see advertised on TV. Most mothers reported hearing their kids sing commercial jingles. Not surprisingly, little kids who often watch TV are more likely to ask for and eat advertised snacks and cereals than kids who rarely watch.

Which makes sense. Because why would companies spend money on advertising if it didn't work? (In chapter 3 we'll find out more about how and why it does.)

Who Knows What

Research psychologists believe that:

Kids under Age 6

- may or may not understand that TV isn't real
- pay a lot of attention to commercials, which they trust
- often don't know the difference between ads and programs, noticing only that the ads are shorter

Kids Ages 6-9

- pay a lot of attention to commercials
- can tell the difference between ads and programs
- begin to recognize that the purpose of ads is to persuade

Kids Ages 10-14

- are less interested in commercials
- are very aware that the intention of ads, unlike programs, is to persuade
- can often identify and explain some persuasive techniques used in ads

Psssst: Pass It On!

On the other hand, advertisers who are trying to influence young people like you don't rely solely on advertising campaigns. They also know that what they call "word-of-mouth" is very persuasive. They've found from experience that if their TV commercial, radio jingle, or free sample wins you over, you might tell others. In fact, once you've seen their movie or bought their shoes, they're counting on you to convince your friends to do so, too.

This doesn't always happen, of course. Not all young people think alike. No doubt you and some of your friends disagree on your favorite music or video game, or wear competing brands of blue jeans. But probably you can find lots of things you do like in common. And advertisers benefit when you recommend your favorites to friends.

Mascot Mania

Need any more proof that advertisers consider kids a valuable audience? Consider the number of companies that create toylike mascots to promote their products. Most of the time, these are designed with kids in mind.

From the giggling Pillsbury Doughboy and the Energizer Bunny, to Ronald McDonald and Frosted Flakes' Tony the Tiger, an effective mascot can make an ad much more memorable.

But some people are upset about the fact that most kids — and adults for that matter! — recognize many more company mascots and logos than they do kinds of birds in their own backyards. Critics are especially angry about

advertising characters that appeal to kids, but are selling products that aren't safe for children to use (the frog used in ads for Budweiser beer, for instance, or the pirate who promotes Captain Morgan's rum).

But here's an interesting question: how many female mascots can you think of?

Girls and Boys Each Sold Separately

Way back, the people who made TV shows believed that women and girls would watch anything that men and boys watched, but that if a show featured too many female characters and seemed designed for female viewers, no guys would be caught dead tuning in. This way of thinking had a big impact on the kinds of programs that got made. Early cartoons — Bugs Bunny, Tom and Jerry, Mighty Mouse, the Roadrunner — had very few female characters. And mascots were almost always male.

In recent years, attitudes have changed a bit as programmers and advertisers have figured out that you can't predict what people will like just on the basis of whether they're guys or girls. Today's cartoons feature many more female characters, including some who kick as much butt as the guys! But toy and game commercials are a different story: many of them still make it look as if we come from completely different planets...

Think about it: the ads for boys' games focus on action, power, speed, and fighting. The colors used are brown and green (like army clothes) or electric blue and bright red: powerful colors. As for the sound, you often hear screeching guitar chords or a rough-sounding male voice speaking really loud and fast — like a radio DJ or the announcer at a demolition derby.

In contrast, girls' commercials mostly feature dolls, fashion, or household activities. Pink and purple are the colors most often used. The narration is usually done by a high-pitched and extremely excited female voice. And the music? Instead of guitar solos, girls' ads feature the kind of stick-in-your-head pop tune that you find yourself humming hours later.

DON'T Try This at Home!

Next time you're watching shows aimed at younger viewers, hit the mute button as soon as the commercials come on. This will help to focus your attention only on the visuals. What do you notice?

Then, during the next set of ads, leave the sound on, turn your back to the TV and just listen to the music and voice-overs. Is it clear from the sound alone whether or not the commercials are targeting boys or girls? Do these kinds of audio and visual cues help you decide when to stick around and watch, and when to run to the kitchen for snacks?

And speaking of snack foods, what kinds of techniques do you notice being used in the ads that want to attract the attention of both girls and boys, like those for potato chips and pop? Do they feature elements common in the commercials aimed at just boys or girls only, or take a completely different approach?

3 AND NOW, A NEWER, HAPPIER YOU!

Can you think of any recent or current ads that send the "Don't be a dork" message? Or how about ones that use the "Buy me and be hip" approach?

These strategies are just two of the many tricks and techniques that advertisers have in their toolkit. In this chapter we unpack that kit to examine the ways in which writers, directors, actors, photographers, food stylists, and special effects people "build" commercial messages. Who knows? You might discover a few pointers about the fine art of persuasion that you can apply in your own life!

Communication 101

Most of us communicate with other people every day, without even thinking about the process. But advertisers think a lot about how communication works. They're always trying to come up with new strategies to make sure their ads are effective. The smart ones conduct research. They survey consumers, asking them what commercials they remember, and whether they've bought certain products over the past month — and if so, why.

> Advertising at its best is making people feel that without the product, you're a loser.
>
> —Nancy Shalek, former president, Grey Advertising

Why do they go to all this trouble? Because the seemingly simple act of communicating is often pretty tricky. Whether you're e-mailing a friend, or talking to your mom, it's easy for messages to misfire and result in misunderstandings. The flow chart below shows the basic process involved when people communicate with one another. Most of the key elements of the process are the same, whether your teacher is assigning homework, or a clothing company is promoting its new blue jeans to millions of people.

Notice how there are two versions of the message? The one sent, and the one received? That's because what you say or write may not be what the other person hears or sees. It's a lot like when your dad tells you to do something, and you think "whenever," and he means "now!"

"Noise" is anything that gets in the way of the message that is sent being received properly. Noise can be actual noise — like a lawn mower or siren drowning out what someone says. It can also be "emotional noise" — like when you're too worried about your lost dog to concentrate in school, or too excited about your team winning the game to hear what your brother is saying.

When it comes to advertising, noise can also be whatever distracts you from paying attention to the message. So if a fast-food restaurant runs a TV commercial aimed at kids, but

uses old-fashioned music, the kids watching might not pay attention. Or say an airline places a half-page ad in the newspaper promoting travel to Europe, and the story on the top half of the same page is about a plane crash that killed 200 people. Readers of the paper may not even notice the ad because of the tragic story. And even if they do, they may be afraid to travel by air because of the news about the plane crash.

Climb Every Mountain — Until You Get a Sale!

Advertisers are keenly aware of the mountain of noise that prevents their messages from being received. In a sense, their job is to climb that mountain, to overcome the distractions that are constantly competing for our eyes, ears, and wallets. The first step involves attracting our attention, and is a bit like finding the right hiking path through the woods. It's still a long way from the top, but they have to start somewhere.

Next, advertisers have to engage our interest long enough for the message to be delivered. Depending on where their ads appear (on radio, TV, or billboards, for example), they may use humor, dramatic images, or interesting music or dialogue to get us to listen to the jingle, stay in the room for the TV commercial, or stop flipping the pages of the magazine long enough to read the ad.

If advertisers accomplish this, and manage to convince readers, viewers, and listeners that the ad is credible — that it tells the truth, and the product really is as good as they claim — they're still only halfway up the mountain.

Stage four of their hike involves sparking our desire for the particular product or service being promoted — making us think, "I want that pizza!" or "I need a new skateboard!" or "I've got to go to Disneyland!"

Once they've got us excited about buying their product or going to their show or theme park, it's like they've climbed above the tree line. Now the top of the mountain is in sight, but the steepest part is still ahead: translating our desire into action — getting us to go out, find the product, and buy it! But as much as advertisers might like them to, ads can't actually pull you up off the sofa and drag you to the store. So instead, marketers concentrate on making it easy for you to access what they're selling.

In other words, in addition to mounting an effective advertising campaign, companies also have to have a good means of distribution. The ones that are successful make sure that their candy bars, dish soap, or running shoes are available in many stores or through the Internet. Big companies often pay chain stores to place their goods at the ends of supermarket aisles, or at eye level, so it's easier for consumers to find them — and harder for smaller companies to compete.

And the top of the mountain? An advertiser can claim to have successfully completed the climb the moment you show up at the store, pull that bag of chips off the shelf, and take it through the cashier.

Don't I Know You from Some…Stereotype?

Advertisers don't have a lot of time to relay their messages. Most TV commercials, for instance, are only 30 seconds long, and some are only half that. Contrast that with the 30 minutes (well, 22, actually, once you factor in the commercials!) of an actual program. How can advertisers possibly tell stories — ones that are interesting enough to help them scale the mountain of noise — in so little time?

One of the strategies they rely on is the use of stereotypes. Advertisers understand that most of us will make predictable associations between certain aspects of a character's appearance and his or her behavior. A kid with thick glasses and out-of-style clothes becomes a fast way to say "smart but nerdy." When we see a woman wearing a white lab coat and holding a stethoscope, we might conclude she's a doctor. And bad guys are almost always dressed in black, like Lucius Malfoy in the Harry Potter movies.

While stereotypes can be very convenient from the advertisers' point of view, they can also be destructive, reinforcing unfair and negative images about groups of people. In fact, some advertisers have gotten into trouble with consumers by using stereotypes. Over the years, women have complained when car advertisers have aired commercials showing female customers who only seemed interested in whether or not the car had a "vanity" mirror. Similarly, men have complained about commercials that show them as being completely incapable of cooking a meal.

PUFF-Busters

Sometimes people upset by stereotypes give the offending advertiser a bit of free advice, as in the graffiti below.

If it were a lady, it would get its bottom pinched.

If this lady was a car she'd run you down.

The beautiful 127 Palio

FIAT

Some advertisers have also been criticized by ethnic minority groups and people with disabilities for either ignoring them altogether, or depicting them in a way that reinforces existing prejudices. This is bad news – and not just for the people who are being stereotyped! Advertisers who insult potential customers – even if they do it by accident – aren't likely to be very successful at selling their product.

~~DON'T~~ Try This at Home!

Does the media reflect your community? Chances are when you look around your classroom, neighborhood or country, you see some mixture of white, black, Hispanic, Asian and/or Native people. Next time you're watching TV or flipping through a magazine, compare the people you know to the ones you see in the media. Does one "community" bear any resemblance to the other? If not, who's missing from the ads? Why do you think that is?

Adapt or Perish

You know the old story about dinosaurs — they became extinct in part because they weren't able to adapt to a rapidly changing environment. Advertisers are familiar with this story, and over the years they've worked hard to make sure they don't repeat the dinosaurs' mistake!

Every time a new form of media has been introduced, advertisers have been quick to figure out the best way of using the new media to promote their products. When radio was invented, they created musical jingles to deliver slogans in a more memorable way. When TV came along, they added moving images and showed people benefiting from their products. More recently, advertisers have developed interactive websites to take advantage of the promotional opportunities offered by the Internet.

They've also had to adapt to other changes in the way people respond to media. Have you ever noticed that the soundtrack of TV commercials tends to be louder than the sound of the programs themselves? Once advertisers discovered that TV viewers would often leave the room during the commercial breaks, they upped the volume to ensure that whoever was off in the other room would still be able to hear the sales pitch.

Also, when television was first invented, remote controls didn't exist. If you wanted to change the channel, you had to get up off the couch, walk over to the TV, and switch the dial manually. That meant the advertisers sponsoring a certain program could be fairly certain that most of the show's viewers would see their ads. But the invention of remote controls changed that. Suddenly viewers had the option of switching stations during the commercials. So advertisers had to develop funnier and more entertaining ways of grabbing viewers' attention in the first few seconds of their commercials, so they would *want* to watch.

Similarly, when the mute button was added to remote controls, enabling viewers to shut off the sound, some TV advertisers created commercials that told the story of their product entirely in pictures. This strategy has helped them adapt to another development: as more and more companies start to sell their products all over the world, it helps to have commercials that don't need to be translated from one language or culture to another. The translation is sometimes tricky because often an image or slogan that's seen as funny or clever in one place isn't understood or appreciated in another.

A recent campaign for Coca-Cola managed to overcome this problem. Broadcast on television and in movie theaters — in places as different as the United States, Japan, India, and Mexico — the commercial features animated polar bears. While tobogganing, the bears work up a thirst for Coke soft drinks. There's no dialogue in the ad so language isn't a problem, and the animals — surrounded only by ice and snow — are not strongly associated with one particular culture. People from all over the world — especially the cold parts! — can relate to them.

On the Language Lookout

On the other hand, language can be very persuasive. When commercials or advertisements do use words, they're very carefully chosen.

Can you think of any ads you've seen recently that included any of the following?

Research has shown that ads featuring these words are especially effective at attracting our attention and selling us products. It's not hard to see why.

But ever since the early days of advertising when patent medicines were popular, some advertisers have used language to deceive people. They can do this in all sorts of ways.

Does your local convenience store label its slush drinks "Giant," "Jumbo," "Mega," or "Max" instead of "Large"? Does the use of one word instead of another make you feel like you're getting more soda? Is there a difference between a "Liter" and a "Full Liter"? A "10-ounce" chocolate bar and a "*big* 10-ounce" chocolate bar?

Say you're standing at the checkout counter and you notice a snack food that's labelled "75% fat free." Since it's generally smart to avoid fatty foods, this might sound like a good thing. But when you think about it, "75% fat free" might also mean that 25 percent of the snack's calories come from fat, which doesn't sound nearly so healthy!

Other words like "helps," "may," "often," and "part of" are considered vague. They're used to qualify advertising promises — to make them less definite. Phrases such as "helps with weight loss" or "may prevent tooth decay" sound good at first, but they certainly don't offer any guarantee. (You could just as easily say "may *not* fight tooth decay"!) Similarly, if the icing-covered pastry is promoted as "part of a nutritious breakfast," is it possible that the skim milk and fresh fruit you eat at the same meal are actually the nutritious parts?

Finally, consider the case of a well-known headache remedy. The makers claimed in a commercial that tests proved that no other pain remedy was stronger or more effective. In fact, the study had actually shown that all of the brands tested were equally effective. So while the ad didn't lie, it created the false impression that its pain reliever was better than the other brands.

DON'T Try This at Home!

Often the biggest difference between products is in the cost — and usually, the ones that advertise the most are more expensive! So here's an experiment you can try next time you're in the supermarket. Head over to the canned soup aisle, and compare the ingredients listed on a can of no-name chicken noodle or tomato soup to the ingredients listed on a brand that you've seen advertised. Based on the factual information on the label — and remembering that the ingredients are listed in order of volume — what differences, if any, do you notice? Is price the only thing that sets them apart? If you put them — or competing cans of cola, or chocolate chip cookies — to a blind taste test, would you be able to identify which was which?

Next, make your way to the laundry section. Look for the small print on the detergent boxes that tells you the name of the company that manufactures each brand. You might be surprised to discover that one company makes both a nationally advertised product and a cheaper kind that you've never seen on TV. In fact, the products may be virtually identical. The cheaper one is designed to appeal to shoppers who are especially concerned about price, while the more expensive, advertised detergent is targeting consumers who may have more money to spend on perceived quality.

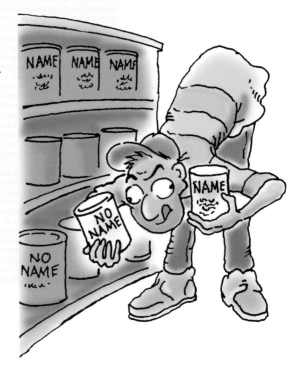

Show Me the Money!

Speaking of spending money, advertising itself is awfully expensive. Take TV commercials, for instance: in addition to paying for the same kinds of costs involved in making programs — for the scriptwriter, director, camera operator, actors, and sound, wardrobe and makeup people — advertisers also have to pay the TV stations for the airtime. And the more popular the show, the more expensive the airtime.

For instance, some popular sitcoms cost up to 9 million dollars *per episode* to make. But the programs attract so many viewers that advertisers are willing to pay more than half a million dollars for a 30-second ad spot. Even if there are only eight 30-second commercial spots shown during each show, that still adds up to more than 4 million dollars for a single airing of the episode. When you consider that each episode will air many, many times because of reruns, you can see how TV networks can make a profit.

Still, you may wonder how advertisers can afford to pay such high rates. Well, think about this: the annual Superbowl football game attracts up to *130 million viewers.* And those viewers are the reason Superbowl advertisers line up to pay a cool $2 million for a 30-second spot. When you do the math, the advertisers are able to reach *each viewer* for less than two pennies.

So it may make sense — and cents! — for advertisers. But what does it mean for consumers? Because we're actually the ones who end up paying for advertising. When we buy a product, the price we pay includes the costs of promoting it. In fact, between 20 and 40 percent of the price of a product is spent on its advertising. So if you pay $50 for a video game or a pair of jeans, as much as $20 of your money may actually be going toward the company's efforts at getting you to buy it in the first place!

What Are We, Cows?!

"Branding" is a term that advertisers borrowed from the ranch. Its original meaning referred to the act of burning the rancher's identifying symbol into the flesh of a cow — leaving a permanent mark, so everyone would recognize whose cow it was. Check out your shoes, computer, bike, or TV. Chances are, their brands are clearly displayed.

The rancher's practice actually has more in common with advertising's version of branding than you might think. When companies create a product, or a line of products, part of their goal is to make the name and logo of their product so familiar to you that it's "burned" into your memory, permanently. Just as with the cow, they want you to recognize their brand forever.

Some companies have been amazingly successful at this. Nike's brand, for instance, is represented by its distinctive "swoosh." The symbol is so simple, and it's seen so often and in so many places, that most of us automatically associate it with the company's name and athletic wear. And not just in North America, but around the world.

In fact, some of the most effective logos have become a new kind of international language — the symbols are recognized by people from many different cultures who speak languages other than English. More and more, advertisers are getting so good at "branding" their products that recent research has found that even babies as young as six months of age can recognize images of corporate logos and mascots.

In other words, before they're even able to walk or talk, babies are being trained as future shoppers.

Counting on Star Power

When you hear the name "Britney Spears" or "Lil' Kim," do you think "pop star" or "salesperson"? Actually, they're both. And like many famous entertainers, these two singers may well make more money from their multi-million-dollar sales jobs (appearing in ads for Pepsi soft drinks and Candies shoes) than they do from making music.

Athletes are also popular among advertisers and many companies in recent years have recruited high-profile sports stars to endorse their products. Hockey great Wayne Gretzky has appeared in commercials for many companies, including McDonald's, Ford, Tylenol, Domino's Pizza, and Upper Deck. And golf whiz Tiger Woods has lent his name, face, and reputation to Disney, Wheaties, American Express, Buick, and Nike.

Does it make sense that more people would buy a product when encouraged to do so by someone famous? Does it pay off for companies who hire celebrities? Consider the makers of Grape Nuts cereal, who wanted to tell people their breakfast food was healthy. When the cereal started to feature a well-known natural foods expert in its commercials, its sales suddenly increased by 30 percent.

But research shows that not all celebrity endorsements are effective. People viewing the ads generally have to believe that the celebrity being featured actually uses the product, and knows a lot about it. So a fashion model, for instance, might be effective at promoting a new clothing line, but not as convincing when encouraging people to buy hamburgers or french fries!

Some North American stars — such as Arnold Schwarzenegger, Brad Pitt, and Madonna — will only appear in ads that air in foreign countries. They believe that endorsing products in commercials is bad for their image as serious actors and entertainers. If that's so, why do you think they don't mind appearing in ads that air in Japan or China?

DON'T Try This at Home!

How many other athletes or celebrities can you think of who have become associated with certain products or companies through advertising promotions? If you see your favorite singer promoting a brand of shampoo, or a famous baseball player endorsing a type of chewing gum, does it make you more likely to want to try the shampoo or gum yourself? Why or why not? Can you think of any products or services that you and your friends might find more appealing if they *were* associated with a particular star?

Repeat after Me

Research also shows that the more a person hears or reads about a product, the more appealing it becomes. A single advertisement is almost never effective on its own; repetition is key. By advertising steadily for six consecutive months, A&W Root Beer, for instance, increased its share of the root beer market by 35 percent.

On the other hand, too much repetition can cause a campaign to become annoying. Have you ever gotten so fed up with hearing the same jingle over and over again that you switched the station? Another problem with too much repetition is that an ad can become so familiar people stop noticing it altogether.

To avoid this, advertisers develop slightly different versions of the same ad, so the product name and slogan are repeated and remembered, but the variation will hopefully keep people paying attention.

It's Everywhere!

- Elevators in some high-rise office towers now come equipped with small TV monitors playing nothing but commercials for the captive audience.
- One perfume company attached scented strips to the backs of Ticketmaster concert envelopes.
- A major American TV network put stickers promoting its new comedy on apples and oranges in grocery stores.

Consumers are like roaches: you spray them and spray them and they get immune after awhile.
—David Lubards, advertising executive

Trick or Treat?

Have you ever convinced your parents to buy you a game or toy you saw advertised on TV and then been really disappointed when you played with it at home? Either the game or toy didn't do what the ad suggested it would, or it just wasn't nearly as fun as it seemed when you watched the ad?

Advertisers employ all sorts of special audiovisual effects to make toys or games appear to be better or more fun than they actually are. Next time you're watching your favorite TV show, pay special attention to the commercials. If you turn off the sound during the video game ad, does it affect how exciting the game looks?

And check out the toy ads targeted to younger kids. Notice the kinds of camera angles used. Sometimes advertisers will make their products look bigger than they actually are by positioning the camera at an angle, and shooting the toys from below.

Another common tactic is to show a toy — whether it's an action figure or a new fashion doll — surrounded by an elaborate set and all sorts of accessories that are sold separately. Even though the commercial might be promoting the main toy "for only $29.99!" you'd have to buy all of the items shown if you wanted to re-enact the activity shown in the commercial, which would cost you much, much more.

Too Good To Eat

Have you ever seen a hamburger or pizza in a TV commercial or magazine ad that looked too good to be true? Well, it probably was!

Advertisers hire special "food stylists" to apply "makeup" to the food, to make it look better than it actually is. Take that juicy-looking burger, for example. Food stylists often smother the meat patty with Vaseline to make it shine, glue extra sesame seeds on the bun, and place pieces of cardboard or plastic wrap between the tomato and the bun to keep the whole thing looking bigger and fresher. In other commercials, white glue is used instead of milk so cereal doesn't get soggy; chicken legs are injected with mashed potato so they look plumper; and hot cocoa is made with dishwashing liquid so the bubbles last longer.

Go figure: to make the food look more appetizing, they actually make it inedible.

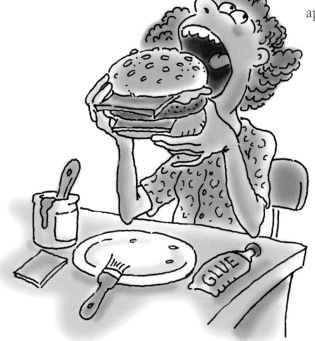

Strategy Toolbox

Advertisers have a lot of other strategies in their toolbox — no doubt you'll recognize some of them. What ads or commercials have you noticed lately that try to appeal to you in the following ways?

Product Wars: The "my dingle's better than your dingle" approach: this can feature a product demonstration or a taste test to support the claim in the ad. The advertiser's hoping that the next time you're faced with the choice between one brand and the other, you'll remember the comparison from the commercial, and buy the "better" product.

Heart Tuggers: Even if there's no violin music, you'll recognize this kind of commercial by its personal story. Designed to put a lump in your throat, these ads (for such things as long-distance phone service or charity fund-raising) play on your feelings, hoping to create a positive emotional connection between you and their product or service.

Excitement Plus!: This is the kind of ad that seems to be shouting, "Get down and boogie!" Lively music and lots of activity — often involving a party atmosphere, or great sports shots — are used to make you think that buying the product will guarantee you a really great time.

Sex Sells is an advertising expression that's been around for a long time. It's used to explain the use of nearly naked models in ads selling everything from shampoo to wristwatches. The expression is based on the belief that exposed skin will attract people's attention.

In fact, although an image of a sexy-looking model on a billboard will get noticed, it won't always help to sell the product. Studies show that people might remember the model (and the absence of clothes) but they often won't recall what was being promoted or why they should buy it.

Some people find the use of sex in advertising offensive, especially if the product has nothing to do with sexuality. Their negative reaction makes them less likely to buy what's being sold.

Stats Unlimited: Also known as "You're too smart to be fooled by advertising" ads. These messages flatter your intelligence by using experts and statistics to help you make a "rational" decision. "Nine out of 10 dentists agree..." says the headline, or "Selected car of the year by automotive journals across the country..."

The Cool Factor: Ah, yes, the tried-and-true "how not to be a geek" strategy. You've seen these ads: the awkward kid suddenly becomes hip by drinking the right pop, or wearing the right clothes.

Turning Caterpillars into Butterflies

When you think about it, the basic elements of the "cool factor" approach show up in many forms of media and storytelling. From the Cinderella fairy tale to the superhero Spider-man, people *love* stories that feature transformation.

Advertisers have figured this out. That's why showing someone or something being changed in a dramatic way has become a common promotional strategy. You've seen the "before" and "after" photographs in magazines showing the effect of a new shampoo or skin cream. In the TV version, a problem is solved (chewing gum gets rid of bad breath) or a riddle is answered (the secret to the neighbor's weight loss is revealed).

The "solution" part of the ad usually implies not just shinier hair, whiter clothes, or a newer, faster car, but that we can receive other things that deep down most of us want even more: to fit in, to be loved and accepted, to be good at something, to have fun, to contribute to others, to be successful.

In fact, some people think that this aspect of advertising is what makes it so powerful. They point out that if people didn't care about these things, advertising wouldn't have so much influence over us. But because we DO care, we're vulnerable to messages promising that our lives will be richer and more exciting.

Of course, most of the time, ads don't come right out and make such promises in so many words. Instead, they paint a picture of good times and warm feelings. They encourage us to imagine ourselves in the situation we're watching, and to believe — without even realizing it — that we can experience the love and success we're witnessing by buying the products they are selling.

When we stop to think about it, of course we know it's not that easy. But we see so many ads, we rarely have time to stop and think about them critically.

PUFF-Busters

Several years ago, an artist who wanted to point out that fear, loneliness, and panic are seldom shown in ads created an unusual campaign of her own. Her billboards consisted of only one sentence each: "I am alone." "I am frightened." "I can't breathe." Because they were so different from all the other ads around, and actually encouraged people to think about advertising in a more conscious way, they really stood out.

Measuring Up

A group of 8- to 11-year-old girls were once asked who their role models were. Many of them mentioned Julia Roberts, who had just become a well-known movie star. The girls said they admired Julia, but knew they could never be as beautiful as she was in the photograph promoting her most recent movie.

But here's the thing: what the girls didn't know was that not even Julia looks as good as the woman in that photograph. Because, in fact, the photograph was actually of *two* women: Julia Roberts' head had been pasted onto another woman's body. As lovely as the actress is, her body wasn't "perfect enough" to appear in the poster for her own movie.

You know from looking around you on the bus or at the local swimming pool that human bodies and faces come in all shapes and sizes. But in the world of advertising, the vast majority of people you see are exceptionally beautiful and extraordinarily thin.

Advertisers think that you'll be more likely to buy products from good-looking people than from average or unattractive people. And they may be right. The trouble is that the pictures of perfection — in movie posters and fashion ads, especially — can mess with your mind.

We've already heard how some advertisers deliberately set out to exploit your fears of being labelled a "loser." That's because they know that it's easier to sell everything from jeans and makeup to diet foods and plastic surgery to people who are afraid they're ugly or uncool.

But, in addition to buying products that may or may not improve their appearance, some people are actually becoming ill in their quest to have a "perfect" body or face.

In our factory, we make lipstick; in our advertising, we sell hope.
—Charles Revson, founder of Revlon Cosmetics

You've probably heard about eating disorders. They mostly affect girls and young women who start to see their bodies in a really distorted way, as if they're looking into a funhouse mirror that makes them seem fat, even if they're not at all. As a result, they adopt extreme dieting or exercise strategies. Guys are sometimes affected by this too, although they're more likely to become convinced that they're too skinny. This can lead them to take special food supplements and drugs that promise to build muscles. Unfortunately, the supplements and drugs often have very serious side effects.

Ads don't cause these problems all on their own; other factors are always involved. But lots of health-care experts agree that commercial messages definitely play a role.

So here's something to keep in mind: when you look at a magazine or billboard ad of a beautiful model — male or female — the chances are that the image has been altered in a big way. (Yes, there's a reason those photos don't look much like the ones you get back from the drugstore!)

PUFF-Busters

In 1995, Kathy Bruin had become so fed up with advertising images of extra-scrawny women that she decided to fight back. She took a photograph of a Calvin Klein Obsession cologne ad, scanned it into her computer and changed the text on the ad to read: "Emaciation Stinks" and "Stop Starvation Imagery." Then she and her friends plastered a thousand copies of the altered poster on construction sites and temporary structures all over San Francisco.

First of all, the model has been professionally made up with loads of cosmetics and photographed under especially flattering lights. Probably the photo itself has been digitally enhanced — computers can manipulate images in amazing ways, eliminating wrinkles, shaving off pounds and adding color to skin and hair. (Makes you wonder what you would look like with all that artificial help, doesn't it?)

DON'T Try This at Home!

Imagine you are an alien from outer space. You've never met a human being before, but you're conducting some research about the people who inhabit the planet Earth. Your sophisticated satellite dish can pick up advertising signals from North American television networks.

Based on viewing the commercials that air during the shows you watch, think about what conclusions you might come to about women and men based on how they look and act, what they're focused on, and how they interact with each other in the ads. As an alien, what would you conclude were the major differences between men and women, or girls and boys?

4 ADVERTISING IN DISGUISE

Has anybody ever tried to trick you into eating good-for-you food that you didn't like by disguising it as something else?

By slipping spinach in between the layers of your lasagna, perhaps, or putting dates in your favorite cookies?

Advertisers are also wise to this strategy. They know that the more conscious you are of the fact that they're trying to sell you something you may not need, the harder it will be to convince you to buy. So they're always on the lookout for new and unusual places to sneak in a promotional message, without making it obvious that that's what they're doing. They dress up their sales pitches in all sorts of "costumes" by giving them bit parts in popular movies, making them look like programs or news stories — or even paying the person next to you to rave about their products. It's like Halloween all year round!

Guerrilla Marketing

Some of these strategies are referred to as "guerrilla" (pronounced "gorilla," but having to do with rebel fighters, not apes!) or "stealth" marketing campaigns. These terms underline the sneakiness of the approach.

For example, Sony Ericsson Mobile Communications recently hired 60 actors and provided them with new mobile phones that double as cameras. Then they got them to hang out at popular tourist attractions like the Empire State Building in New York and Seattle's Space Needle. But the actors weren't being paid to see the sights. Cast as "fake tourists," their job was to ask unsuspecting passersby to take their pictures. Another 60 actors were hired to hang out in trendy bars, engage strangers in conversation, or play with their phones in a part of the bar where they would attract attention. The point was to get people talking about the new mobile phone without letting them know that the "owners" of the product were simply being paid to promote it.

This approach received mixed reviews. Some consumer activists thought the practice was dishonest and shouldn't be allowed. They argued that the actors should have had to wear Sony Ericsson T-shirts or tell people they worked for the company. But the marketing firm that dreamed up the idea defended it, saying the actors weren't trying to sell the product, just demonstrate it.

What do you think? Would it bother you if you found out only by accident that the person you were talking to about a new bike or computer game was being paid to tell you it was great?

The "Cool Hunt"

Another guerrilla marketing approach involves advertisers taking advantage of the influence kids have over each other. They start by seeking out teenage fashion leaders to find out what's considered "rad," or "hot," or "cool." Advertisers call this the "cool hunt."

It works like this: companies such as Reebok go looking for cool kids in big cities like New York, Chicago, or Los Angeles. They go into the hippest stores or clubs seeking out kids who are so cool they don't *follow* fashion trends, they *create* them.

The companies find out what these kids are interested in — whether it's bleached hair, vintage clothing, or a new kind of music. They ask the kids what they think about a new product they're starting to make and get feedback about how it could be made to look more "cool." And then they go back to their factories and quickly begin manufacturing and advertising based on the advice they've gotten from the cool kids.

The companies are counting on other kids, who look up to and follow the lead of the cool kids, to buy those products.

Adults who hang out with young people are also recruited to be walking/talking advertisements. One company gave its new brand of athletic shoe to a carefully selected group of school basketball coaches. In exchange for the free shoes, the coaches had to promise that they would promote the shoes to all the kids they coached.

Movies are another popular hiding place for sneaky advertisers. Have you ever seen *E.T.: The Extra-Terrestrial?* It's become one of the most popular movies of all time. It also represents a landmark case in the history of advertising.

The producers of *E.T.* approached the makers of M&Ms chocolate candies and offered them an opportunity to have their candy featured in the movie. M&Ms turned down the invitation. Instead, when the film opened on thousands of movie screens across North America and eventually around the world, a supporting role was given to Reese's Pieces candy. In a now-famous scene, the young boy in the movie left a trail of Reese's Pieces candies in his backyard in order to entice the lovable E.T. into his house.

Coming soon to a theater near you:
"BUY NOW" starring Junk Food and Cell Phone!

Bogus Mind Control at the Movies

In the 1950s, people got very excited about a thing called "subliminal advertising." James Vickery of New Jersey said he'd fixed up a movie projector with a special device that flashed the words "Eat popcorn" or "Drink Coke" onto the screen in the middle of the movie. The words supposedly appeared so quickly and for such a brief time that viewers didn't notice them. This is where the term "subliminal" comes in; it means something that you're unaware of. Vickery claimed that as a result of this new form of advertising, soft-drink sales increased by 18 percent at the theater and popcorn purchases shot up by 57 percent!

You can imagine the reaction: advertisers couldn't wait to try it out, ordinary people became afraid that they were going to be brainwashed, and some governments immediately forbid theaters and television stations from using the technique.

As it turned out, the whole thing was a big hoax. When some researchers attempted to test the device and measure the effectiveness of subliminal advertising, they found that it didn't even work!

As a result of the movie appearance and the "tie-in" advertising that promoted both the candy and the film, sales of Reese's Pieces candy soared by more than 60 percent.

Movies haven't been the same since. "Product placements" have become more and more common. They can be as simple as a Diet Pepsi bottle sitting on someone's desk in a scene, or a character referring to a particular store. Budget Rent-a-Truck had a starring role in the popular *Home Alone*, and the James Bond film *Die Another Day* took the trend to an extreme, giving screen time to Visa credit cards, Omega watches, Finlandia Vodka, Bollinger champagne, Sony Ericsson electronics, Ford cars, Heineken beer, and Norelco razors. In fact, some critics and moviegoers objected to having to pay to watch what they said looked more like a two-hour commercial than a movie!

Television shows also accept ad dollars in exchange for putting products in front of the camera. Sitcoms and reality-based TV series have featured everything from cereal and cars to hair spray and electronic equipment. Scriptwriters for the long-running ABC soap opera, *All My Children,* came up with the idea to incorporate the cosmetics company Revlon into three months' worth of the show's episodes. Even though Revlon employees were referred to by one of the program's characters as "vultures," the company paid several million dollars for the increased profile it got through the show.

DON'T Try This at Home!

Next time you're watching a movie or TV show, keep an eye out for product placements, and count up how many you see. Compare the exposure a product gets in a TV show to the kind of profile it might be given in a commercial. Which one are you more likely to remember or talk about with friends? Do you have to hear a sales pitch in order to be persuaded? And does it make a difference to the audience whether it's a villain, a hero — or an alien! — using the product?

INFOrmation + comMERCIAL = INFOMERCIAL

It used to be that the US government restricted how much time during each hour of television could be devoted to commercials. But in 1984 the rules changed, opening up new opportunities for advertisers. As a result, "infomercials" were born.

In the TV schedule, these "shows" are listed as "paid programs" — which makes it clear that they're actually advertisements. But when you're flipping from one station to another and you come across an infomercial, it often looks a lot like a regular talk show or news report. Sometimes you'll see an "expert" explaining how or why something works; other times there will be a studio audience with apparently regular people describing how a product helped them.

Just like on normal programs, these conversations will be interrupted by commercials. It's strange to think that a 30-minute commercial would have its *own* commercials, but one of the goals of the infomercial is to make you *think* you're watching a normal show — a show in which the people promoting a new money-making scheme, beauty product, or piece of fitness equipment aren't being paid to do so! Advertisers hope that if the show features regular commercials, viewers will be more likely to believe that the pretend interviews are real.

And if you think that the claims being made in some of these infomercials seem too good to be true, guess what? You're right! The US Federal Trade Commission warns that lots of unsuspecting people have been hoodwinked into spending money on rip-off hair-growth treatments, real estate scams, or weight-loss programs that didn't work, as a result of certain "paid programs."

Infomercials can be easily identified by the following signs:

- as a dead giveaway, the show focuses on only one product;
- in an amazing coincidence (not!) the commercials promote the same product as the show;
- "how to order" information takes up as much screen time as the expert "interview";
- they keep reminding you that supplies are limited and you'd better rush to the phone and buy the product *today*.

Say you get hooked in by an infomercial anyway — maybe it's a product that really impresses you. Just remember that:

- "get rich quick" schemes are almost always scams;
- "testimonials" rarely reflect the experience of most people; and
- the people in the infomercials aren't "independent experts" but sales agents paid to sing the products' praises.

Are you talking to *me*?

Advertisers aren't allowed to target kids under the age of 12 with infomercials. In the United States, the Children's Television Act of 1990 made sure of that. Only 12 minutes of commercials are allowed during each TV hour designed to appeal to kids on weekdays, and only 10.5 minutes are permitted on weekends. On Canadian shows for kids, only 8 minutes of ads are permitted.

Saturday Morning Rule Breakers?

Some people argue that clever advertisers are breaking the rules with program-length commercials for really young kids. They point out that Saturday morning TV features all kinds of shows that were invented just to sell toys. *Sailor Moon, Care Bears, Pokemon,* and *X-Men* may look like regular cartoons, but they're actually produced by the companies who make the toys of the same name as a sales strategy.

Cereal manufacturers are also big-time advertisers on Saturday morning television — no doubt they're hoping to influence what kind of breakfasts young kids will ask for. And recently, companies hit on yet another way to reach kids before they've even outgrown their diapers! The *M&M Brand Counting Book* and *Oreo Cookie Counting Book* are designed for toddlers who are just learning to count. In fact, when toddlers and parents read the books together, they have to have a supply of the sweet stuff on hand — for counting and, of course, for eating!

Some adults think these books are a great idea. "Anything that encourages children to be interested in reading is good," they say. But many others — including doctors — are dead set against them. They argue that it's not fair to target kids so young, or to encourage combining food with learning, which may lead to bad eating habits that adversely affect their health.

Music Television: *All* Advertising, *All* the Time!

When you switch on music television, chances are you're not thinking, "Hey, let's check out some advertising." But when you consider it, that's what music videos are: ads for CDs. The "video ads" on MuchMusic and MTV are so entertaining that viewers tune in just to watch them.

Music videos can be very expensive to make, but recording companies give them to TV stations free. They know that every time a music video is aired, it's like a three- or four-minute commercial for the performer's CD.

And the Ad Goes to...

The promo atmosphere of music television is so accepted that nobody thought twice when recording artist Macie Gray wore a dress to the MTV awards broadcast in 2001 that really did the job of a billboard. Across the front of her dress was printed the release date of her newest album, and across the back were the words "BUY IT." Not all musicians are eager promoters, though. Long-time recording artist Neil Young taped a video for his song, "This Note's For You," which was about how he refuses to appear in ads for Pepsi or Coca-Cola. Executives at MTV, realizing that soft-drink companies are big advertisers on their station, refused to air Neil Young's video. But the musician had the last laugh: his video later won the station's award for "Best Video of the Year"!

On the other hand, just because the videos do double duty — as entertainment *and* advertising — doesn't mean that people don't want to tune in to music television. MTV, MuchMusic, and Country Music Television (CMT) give viewers the chance to preview the songs and consider ahead of time whether they want to spend their money to buy an album or not. But it's interesting to wonder if some songs "sound" better when accompanied by moving images. What happens when you get the CD home and listen to it without the video?

Who Decides?

Because TV broadcasters, magazines, and newspapers rely heavily on advertising income, the companies who advertise regularly have a lot of influence — direct and indirect — over what gets aired or published. An advertiser who is spending a lot of money to promote a product doesn't want the ad's effectiveness to be undermined by what comes before or after it.

For example, cosmetic companies have pulled their ads from magazines that didn't feature women wearing makeup on their covers. Liquor companies have threatened to withdraw their advertising from publications that printed news stories about alcoholism and the health problems caused by drinking too much.

You can see why this kind of censoring influence isn't a good thing for the public. We tend to believe that the news media are working for *us* — sharing information that's important for us to know. But their dependence on advertisers sometimes means that they put advertisers' interests ahead of readers' or viewers' interests. News about the side effects of a new drug or the performance of a particular car might get downplayed or left out altogether as a result of advertiser pressure.

When Is a Magazine Not Really a Magazine?

Other companies have found a way to ensure that the magazines in which they advertise offer an environment that encourages people to buy their products: instead of placing their ads in regular magazines, these companies create their own! Some clothing manufacturers, coffee companies, and drugstores have abandoned sales catalogs altogether in favor of glossy "magazines" that include articles as well as ads. But if you read the articles carefully, you begin to notice that they're really just ads with a lot more writing and fewer photographs.

It's All in the Family...

Regular magazines also provide "invisible advertising." For instance, many magazines are now owned by larger companies that also own movie studios, television channels, and even toy manufacturers. Having all of these organizations in the same "family" makes it easier and less expensive for each one to promote its products.

It works like this: Say "Dad's Studio" puts out a new movie called *Revenge of the Techno Wizards*. "Mom's Magazine" then puts a photo of the movie's director on its cover, and writes a glowing review of the film telling everyone to go and see it. Meanwhile, "Brother's TV Station" airs trailers for the movie and broadcasts interviews with the movie's stars. Finally, "Sister's Toy Company" creates a line of Techno Wizard character toys to sell to kids.

Even though the trailers shown on TV are the only obvious "commercials," the movie is being promoted in all sorts of other ways that don't really seem like advertising. And people who are exposed to even one or two of the interviews, articles, or photos, not knowing that all of the messages are coming from the same company, may get the impression that this movie must be a good one — just because everybody's talking about it! This may or may not be true, of course, because you can't always trust all the good things one "family member" says about another!

Flak Artists and Spinmeisters

Ever been to the circus? If so, you may have heard of P.T. Barnum, of Ringling Brothers Barnum and Bailey's fame. Many people consider this 19th-century circus promoter the first master of "public relations," or PR for short. People who work in public relations help companies, organizations, and individuals present a positive image to the public. "Flak artists" and "spinmeisters" are slang terms used to describe them; they're said to "spin" good news stories about their clients and to take the "flak" when something goes wrong.

What's the difference between advertising and PR? Whereas many people recognize advertising when they see it, a lot of PR — especially if it's done well — isn't at all apparent to the average person.

A surprising amount of what we see or hear in information media — including newspapers, magazines, and TV and radio news and interview programs — shows up because someone has paid to get it there. They haven't produced a commercial or created a print advertisement, but they've persuaded the reporter or editor to profile their product or service as if it were genuine news.

Just to be clear, most of us understand "news" to be recent, current, or future events that are important or interesting to people. Now, we're sometimes interested in hearing about new products, but let's face it, compared to what's going on in the world, most advertised products aren't so unusual or special that they deserve to be featured in newspapers or on the daily news! Nevertheless, many news shows and publications contain a lot of public relations stories. Take an example from Kentucky Fried Chicken — now known as KFC.

When KFC launched its new product, Kentucky Nuggets, other fast-food restaurants already carried similar menu items. But KFC wanted to convince people that their nuggets were

Why Did the Chicken...?

Can you guess why Kentucky Fried Chicken changed its name? In the 1980s when people started to become more aware of the importance of eating healthy food, research showed that customers didn't like being reminded that they were eating stuff that was deep fried — most of us know it's fattening. So the company's PR advisors put the company name on a diet, reducing it to only its initials: KFC. This change solved the problem, the PR advisors figured: the fried chicken is just as fattening as it was before, but people aren't as conscious of it now!

worth trying. So, in addition to advertising the new product, they launched a PR campaign in an effort to get profile in the news media, too. They knew that when people hear about something through the news, as opposed to through advertising, they're more likely to believe it.

Since nuggets themselves weren't new, they needed another "story angle" to interest reporters and talk-show hosts. Someone hit on the idea of using the two daughters of Colonel Sanders — he's the old white-haired guy who invented KFC's "secret recipe" and whose face appears on the buckets of chicken.

A PR agency was hired to call up newspapers, and radio and TV stations and convince journalists that they just *had* to interview Margaret Sanders and Mildred Ruggles. As it turned out, many reporters were curious to meet Colonel Sanders' daughters, and the two women — who were senior citizens, spoke with strong southern drawls, and had white hair, just like their dad — charmed everyone.

The PR campaign was a big success. Newspapers wrote stories featuring big photos of Mildred and Margaret, and radio and TV hosts interviewed the sisters on air. What did they talk about? Their famous father, of course; the state of Kentucky where the company got its start; and most of all, the new chicken nuggets! KFC was very happy. Instead of spending hundreds of thousands of dollars for expensive TV commercials, they paid a fraction of that amount to the PR agency and got news coverage instead.

Thousands of companies, nonprofit organizations, governments, and individuals (ranging from politicians and business executives to actors and athletes) also use public relations campaigns to promote who they are or what they do through the news media. Strictly speaking, the campaigns aren't advertising, but in many respects they serve the same purpose.

5 CAN THEY *DO* THAT?!

Have you ever seen an ad that stopped you in your tracks and made you scratch your head and wonder, "Whoa! Are they allowed to *put* that on television?!"

Or maybe you've done a double take at the sight of a billboard and thought, "That's how to make someone drive off the road!"

If so, you're not alone. People have been upset by advertisers' ridiculous claims, as well as by sexually explicit or violent advertising, for a long time.

FREE SKATEBOARDS FOREVER!

Magnificent Promises, Outrageous Lies

Even though advertising has been around for thousands of years, rules about what advertisers could do or say were only introduced in the last century. The "magnificent promises" (or outrageous lies!) that Samuel Johnson complained about in the 1750s continued into the early 1900s. But by then some people were getting really angry about false advertising claims. They started to organize a protest movement and demanded that authorities do something to protect consumers from unscrupulous advertisers. As a result of this pressure, governments in the early part of the 20th century started to introduce some guidelines — especially regarding ads for food and drugs.

But then during and after the First World War, people had other things to worry about and the rules were more or less forgotten. By the 1920s, some advertisers were resorting to scare tactics to try and stand out from their competitors. Scott Paper Company, for example, told consumers that, "A single contact with inferior toilet tissue may start the way for serious infection — and a long and painful illness. " Listerine went even further with an ad that described a woman who came home from a party and caught a chill and died because she failed to gargle with the miraculous mouthwash!

Clearly these claims were massive exaggerations and should never have been permitted. But people were used to hearing such whoppers from the makers of patent medicines (remember Lydia Pinkham's Vegetable Compound in chapter 1?), so it was hard to get them excited enough to lobby for change. Then in the 1930s, with the Great Depression, a lot of advertising disappeared as people stopped buying and companies went out of business. In fact, it wasn't until the late 1950s that someone first gathered the resources necessary to take an advertiser to court.

By the 1960s, regulatory agencies were formed — Advertising Standards Canada and the Federal Trade Commission in the US. Finally, during the 1970s, the US Federal Trade Commission (FTC) started making deceptive advertisers pay for their lies. Interestingly, among the companies forced to "eat their words" were the makers of Listerine: they were ordered to spend $10 million letting consumers know that, "Contrary to prior advertising, Listerine will not prevent colds or sore throats or lessen their severity." The FTC also began demanding that advertisers in certain industries submit evidence proving their ad claims.

These days there are all sorts of rules and regulations that advertisers are supposed to follow — especially when they're advertising to anyone under the age of 12.

In many countries — such as Greece, Norway, Denmark, Sweden, and Belgium, for instance — advertisers are not allowed to target their sales pitches to kids at all! Even here in North America, the Canadian province of Quebec forbids advertising to kids under 12. Can you imagine what it would have been like to grow up without seeing commercials during your favorite shows? Would you have missed them?

Official Do's and Don'ts

Here's what the rules say about how North American advertisers should behave when they're encouraging young kids to buy their products. (Canadian and US regulations are similar, but not identical. To find out exactly what's allowed in your country, check out the notes at the end of the book.)

1 **No** exaggeration allowed. This covers not just what the ad says, but what it shows: for instance, the advertiser can't use special effects to make the toy look bigger, go faster, or do things — like come to life — that it can't really do.

2 **No** promoting products to young kids that are only suitable for older kids or adults.

3 **No** telling kids that they "have" to buy the product, or that they "should get their parents" to buy it for them. An advertiser can say, "This doll is available at ABC Store," but not, "Ask your mom for this doll."

4 **No** telling kids that if their parents don't buy it, they're mean, or if they do, they're more generous than those who don't.

5 **No** using well-known kids' entertainers, cartoon characters, or puppets to endorse or demonstrate a product unless the character was actually created by the company specifically for the product — like "Mario" for the Super Mario Brothers video game.

6 **No** promoting craft and building toys that are too difficult for most kids to put together. If the product does need to be assembled, the ad must say so using words that can be understood by the targeted age group.

7 **No** showing stuff in the ad that's not included with the toy, unless it's clearly stated — such as "batteries not included," or "PlayStation sold separately."

8 **No** showing dangerous activity. When ads feature cycling or rollerblading, for instance, the kids must be wearing protective helmets or safety pads. If they're jumping on a trampoline, adults must be shown supervising.

9 **No** featuring violence or other activity that's inappropriate for kids to see and that might frighten or confuse them.

10 **No** telling kids that if they don't buy the product, they won't be popular, or if they do buy the product, they'll be smarter, stronger, skinnier, or cooler.

11 **No** using social stereotypes in ads or encouraging kids to feel prejudiced against a certain group or "kind" of person. Advertisers are also supposed to try to include kids of all colors and abilities in their ads.

12 **No** using words like "rush down" or "buy now" to make kids think they have to buy a product right away. And no using words to make the price sound low, like "bargain price" or "only $2."

13 **No** telling kids to call a toll-free line, give out personal information, or buy something off the Internet without first telling them to check with their parents.

14 **No** creating false expectations in kids about their chances of winning giveaway prizes. Advertisers have to clearly state what the likelihood of winning the prize is.

15 **No** using the words "new" or "introducing" for more than one year and no trying to convince kids that last year's toy is no longer any good now that a new model is available.

Do you think Tom Waits might have had the following department store ad in mind when he wrote the song lyrics at left?

almost **all** *furniture & sleep sets* **on Sale** *Plus, it's like there's* **NO TAX ADDED** *on almost all furniture and sleep sets*

> The big print giveth and the small print taketh away.
> —singer Tom Waits, in "Step Right Up"

What words do you read first? Have a look at the small type — are there words there that you would consider "vague"?

What Do You Mean, There Are No Ad Police?

In the US, advertisers operate on an honor system; they're just expected to know and obey the regulations set out by the Children's Advertising Review Unit (CARU) of the Council of Better Business Bureaus, an industry organization. In Canada, every advertisement targeted to kids — whether television, radio, or magazine — has to be submitted to another industry organization, Advertising Standards Canada (ASC), for approval before it gets broadcast or published. The advertisers even have to pay a fee to have their ads approved.

In both countries, there are also some guidelines for how advertisers should behave when pitching their products to adults. Would it surprise you to learn not every advertiser pays attention to the guidelines?

When companies do break the rules, there aren't exactly any "ad police" patrolling the airwaves, searching newspapers and magazines or investigating billboards to give the offenders

a ticket or lock them up. Most of the time, unless consumers (that would be people like you and me!) make a fuss, advertisers can just go on breaking the rules.

SO if we want advertisers who are stretching the truth or showing dangerous behavior to clean up their acts, we have to:

1 know the rules in the first place;

2 remember exactly when and where we saw the deceptive ad, and what it claimed;

3 know whom to complain to;

4 take the time to complain; and

5 do it in writing, because advertisers often pay much less attention to phone calls.

That's a lot of work for consumers to do. In fact, research suggests that it's too much work and, as a result, most people who see advertising that they think is irresponsible or deceptive don't bother to tell the advertiser or the authorities. Instead, they just gripe to their friends. This is still bad news for the advertiser, because we're often more influenced to buy a product or go see a movie by what our friends say than we are by advertising!

Out of Bounds

here is one medium where it's especially difficult to make people and companies stick to the rules: the Internet. Because what's on the Net is simply "out there" and the information and images cross international boundaries, it's not always clear how to enforce regulations established by any one country.

Some people are less concerned about what advertisements *say* than *where they are*. Can you guess which of the following promotional strategies generated the most negative reaction?

- advertisements for a Batman movie projected on sidewalks
- painting an entire street — the pavement, the houses, the trees! — in Salford, England the color of pink bubble gum in celebration of "Barbie Pink Month"
- Pepsi and Coke soft-drink ads painted on the Himalayan Mountains in India

Although all three promotions got people upset, India's Supreme Court ruled that the actions of the soft-drink companies had put the sensitive ecosystem of the Himalayas at risk. The court fined the makers of Pepsi and Coke soft drinks for causing environmental damage.

DON'T Try This at Home!

Next time you're reading a magazine or watching a TV program designed especially for kids, pay attention to the commercials. See if you notice the advertisers obeying — or not obeying — the rules. Are they using language that exaggerates, or showing a situation that suggests you'll be more popular if you own their product? Do they tell you to "buy *now*" or call a toll-free line? Check their approach against the rules listed.

Does knowing what advertisers are allowed and forbidden to do change the way you watch the ads? Are you more aware now of the tricks they use to catch your attention than you were before?

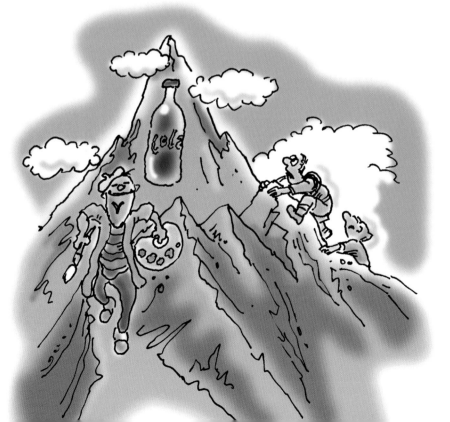

Caution:
Four-Year-Olds Are Watching

In the early 1990s, a blue jeans company put up a billboard in many North American cities. The black and white image on the billboard featured a man and a woman who were soaking wet. It looked as if the man was pushing the woman up against the wall of a shower stall, holding her arms to stop her from getting away. The woman's head was bowed and her wet hair was falling in front of her face so you couldn't see her expression. Another thing you couldn't really see were the blue jeans. She wasn't wearing any, and the photograph showed only an inch or so of his!

The billboard company got a lot of calls from people who didn't think this image should be plastered on street corners. One of the calls was from a woman who said that her four-year-old daughter had asked: "Mommy, why is that man hurting that woman?" As a result of the complaints, the jeans ad was taken down.

Outdoor advertising — on billboards, transit shelters, or the sides of buses — is different from other forms of advertising because it's seen by almost everybody. You choose to tune in to a particular radio station or TV program. You decide which comics, magazines, or newspapers you want to read. But advertising that is outdoors is often unavoidable; you don't choose it, it's just there!

Because of this fact, some people believe there ought to be different rules for outdoor ads — especially keeping in mind that four-year-olds see them. What do you think?

Smart advertisers and billboard companies tend to be more careful about what images they put up outside because they don't want to have to take them down if people complain. On the other hand, a couple of clothing companies have been accused of running deliberately controversial billboard campaigns just to attract attention and generate news coverage. For example, some people say that Benetton and Calvin Klein have used images that offend people in order to create "buzz" and hopefully increase sales. Even though they were sometimes required to remove their ads, they got as much or more attention because of them—through news coverage— than if they'd used less offensive images that stayed up longer.

Do you think this is a good strategy?

Brains Sold Separately

Other advertisers have gotten into trouble for featuring behavior or activity that was downright dumb. Consider these candidates for the Stupid Advertiser Tricks Award:

- A few years ago, a beer commercial showed one guy pushing another really fast down a steep city street in a shopping cart. It was hard to watch the ad and not envision the injury or even death that was likely to happen at the bottom of the hill.
- Another TV commercial for a radio station showed two guys setting fire to a paper bag, placing it on somebody's doorstep, ringing the bell, and then running away. This was followed by the sound of the homeowner trying to stamp out the fire with his feet and screaming.

I think that I shall never see.
A billboard lovely as a tree.
Indeed, unless the billboards fall
I'll never see a tree at all.
—Ogden Nash, American poet

- A magazine ad promoted the services of a marketing company by featuring a young child hanging from a clothesline with clothespins. He was clearly stranded and couldn't get down.

Regulators rapped the knuckles of all three advertisers for featuring dangerous or abusive behavior, and the ad campaigns were cancelled.

DON'T Try This at Home!

Have you seen a promotional message lately that made you wonder if the company had checked its brain at the door when approving the idea? If so, you could write them a letter telling them why you think the ad is dangerous and what you think they should do about it. Send a copy to the proper reviewing agency, too. You can usually find companies' mailing addresses through a search engine on the Internet. Be sure to ask for a response to your letter. (Chapter 6 has more tips on giving companies feedback about their advertisements.)

With Friends Like Joe, Who Needs Enemies?

But some people think the most abusive advertisements are the campaigns designed to get people — and especially kids — to smoke. And it's not like we haven't all heard about the number of smokers who will die of smoking-related causes!

Not surprisingly, tobacco companies aren't allowed to advertise to kids — or even teenagers. And in Canada and Europe, they're not allowed to promote cigarettes to adults either, except by sponsoring sporting and cultural events. Ads for these events may include the logo of the

Smoking Hollywood

Since TV advertising of cigarettes was banned in the 1970s, tobacco companies have turned to movies instead. The result? Although cigarette smoking in North America is actually declining, 9 out of 10 Hollywood movies during the 1990s included the use of tobacco, and one in five kids' movies showed cigarette logos! Which just goes to show that "reel" life is not exactly *real* life. The smoking rate among major characters in movies is about *300 percent higher* than it is among real people. In movies, smokers tend to be powerful and successful; in the real world, that's not necessarily the case. And how often have you seen anyone in a movie complain about secondhand smoke or the stench of a smoker's kiss!?

tobacco company, but not show people smoking, or describe the features of the cigarettes they make.

Before these rules were developed, tobacco manufacturers tried a variety of strategies to attract the attention of young people. As one company marketing report stated, "Today's teenager is tomorrow's potential regular customer."

Cigarette advertisers know that they have to get you when you're young, because chances are once you're in your 20s, you won't think smoking is cool or glamorous anymore.

One tobacco company in particular developed a campaign designed to appeal to very young children. In 1987, R.J. Reynolds created a cartoon camel named "Joe" to promote Camel cigarettes — and we all know that little kids are the biggest cartoon fans. Joe was featured in a series of advertisements doing cool stuff, like playing in a rock band, shooting pool, and riding a motorbike. In addition to appearing in magazines and on billboards, Joe also showed up on T-shirts and baseball caps. In fact, the campaign was so successful that a study done only four years after the cartoon camel was introduced found that he was as recognizable to kids as Mickey Mouse!

Another study found that before the creation of Joe, less than one percent of kids under 18 who smoked, smoked the Camels brand. Four years after the cartoon character was introduced in millions of dollars' worth of ads, more than 32 percent of the same group smoked Camels cigarettes.

There's no doubt that R.J. Reynolds was working hard to get kids to identify with Joe Camel so that eventually the kids would get hooked on their cigarettes. Fortunately, after many people complained, the US government finally told the tobacco company in 1997 that it had to stop using the cartoon character. Unfortunately, the ban only affects advertising in the US, so Joe is still out there pushing cigarettes to kids in other countries where tobacco advertising is permitted.

The Marlboro... Woman?!

Did you know that Marlboro cigarettes — famous for hundreds of ads featuring macho-looking cowboys riding their horses on the range — were originally marketed as a *woman's* cigarette? Hard to believe, until you remember that often the only thing that makes one product different from another is the kind of pictures that are used to advertise it.

When they were first manufactured in 1902, Marlboro cigarettes featured a red tip designed to hide lipstick marks. But 50 years later, the company started advertising the product to men, and by the early 1960s, they had figured out that whenever their ads featured cowboys, sales increased. So the now-familiar "Marlboro Man" was born. By 1972, Marlboro was the best-selling cigarette in the world. Thirty years later, it still is.

But some people are trying to change that. In the last decade, several actors who appeared in the cigarette ads as "Marlboro Men" have been diagnosed with, and eventually died from, lung cancer. At least one went public with his illness, calling on the company that makes the cigarettes to stop advertising.

If You Can't Beat 'Em, Join 'Em

For years, health authorities have tried to come up with anti-smoking campaigns that would be more persuasive than the tobacco company ads. Recently they've started recruiting famous fashion models, actors, and musicians to deliver the message that smoking is ugly, not to mention bad for you.

Do you think actor Elijah Wood or the members of BoyzIIMen are likely to be more persuasive than teachers or parents? Why or why not?

DON'T Try this at Home!

Ask your friends, family, or teachers what kinds of ad locations, if any, they think shouldn't be permitted. Find out if they're aware of the existing laws and regulations. Do they know who came up with these rules and what the penalties are for advertisers who break them? And have they ever complained to an advertiser themselves? How? Did they write a letter, make a phone call or send an e-mail? What kind of response did they get, if any?

It's Everywhere!

Picture this: you're driving along a country road, gazing out the window at some cows in a farmer's field, and suddenly you realize that the animals — no way! — have been painted like billboards. It could very well happen. A Swiss company called Cow Placard Co. has been set up to give "branding cows" a whole different meaning. For $375 per cow, they'll paint an advertiser's brand name or logo on the slow-moving beasts. Would it surprise you to learn that animal rights groups weren't impressed?

6 KID POWER

Say your favorite group or singer is coming to town, and you're saving up to buy a ticket.

When you're thinking about what it will be like to attend the concert, do you get more excited about hearing the band and watching the light show or buying a T-shirt? A lot of advertisers assume you want the T-shirt. A concert promoter named John Roberts once said, "If a kid went to a concert and there wasn't any merchandise to buy, he'd probably go out of his mind." Talk about stereotyping!

Sometimes the assumptions that advertisers make about what's important to kids are wrong. Have you ever seen an ad that showed kids your age playing with some toy that you're way beyond and wondered, "What were they thinking?"

Unclear on the Concept

What's the best way to get advertisers who underestimate you to smarten up? Get in touch and let them know what you really like or don't like.

Back in chapter 2 we talked about how important young people are to advertisers — how they're always on the lookout for new ways to reach you and sell you stuff. The good news about this is that it means they care what you think. If you take the time to give them feedback, chances are they'll listen.

You have power. Let's call the power you have the "Three C's": Consumer Power, Companion Power, and Complaint Power. And you're in charge of how and when they get used.

Consumer Power

Every time you pull a quarter or a dollar or ten dollars out of your pocket, you're using your "consumer power." You're deciding how and where and on what you're going to spend your money.

But what then? What if you buy a game that falls apart after two weeks even though you used it exactly like the kid in the TV commercial did? Do you shove it to the back of your closet and then forget about it? Do you take it back to the store and request a refund? Or do you make a mental note of the name of the company that made it, and remind yourself to avoid wasting your money on their games in the future?

This last option is called a "boycott" — it refers to the decision people make to refuse to do business with a particular organization. In the past, people have boycotted TV stations for broadcasting too much violence; they've boycotted food and clothing companies for taking advantage of poor people in less fortunate countries; and they've boycotted perfume and beer advertisers for producing commercials and magazine ads that portrayed women as if they were objects to be bought and sold, instead of as human beings.

Does it make much of a difference to a company if you stop buying their products or watching their shows? Maybe not, if you're the only one. But it's still worthwhile. Your choice to boycott gives you a way to say, "I think this company is irresponsible and dishonest. I don't support what they're doing or saying, and I'm going to do something — however small — to protest."

On the other hand, if you want your protest to make an even bigger difference — to change the way a company makes its toys or advertises its products — Companion Power and Complaint Power are good ways to increase your impact.

Companion Power

Say you're at a hockey or basketball game, and you stand up with your arms raised over your head. The only people likely to notice are the folks sitting next to or behind you. But if a whole bunch of people stand up all together or in a "wave," everybody notices!

The same principle applies when it comes to consumer protest. If you see an ad on TV that makes "Ramma Gamma X Star" look like the greatest game ever, but you know from experience that it's actually really boring and nothing like the ad suggests, you're likely to tell all your friends. Then if your friends tell their brothers and sisters, who tell their own friends, who then tell even more people... Well, you get the picture — it's like "the wave" at the sports event — it's pretty hard to ignore! A "wave" of consumer power — in which a lot of "companions" stop buying a company's products — is more likely to get noticed.

Complaint Power

If you *really* want the company to change what it's doing —
in the ad, at its manufacturing plant, or in another country —
the best thing to do is talk to the company directly. A phone
call is more powerful than simply telling your friends, and an
e-mail is even better, but companies take letters that come
through the mail most seriously of all. A letter seems more
real somehow; it's harder for people to throw it away than it is
for them to delete an e-mail or phone message. And a letter
takes more time to write than an e-mail or phone call, so
companies know the writer is serious. If more than one
person writes to a company expressing concern about the
same thing — combining Companion Power and Complaint
Power together — that's even better!

Zapped!

Here's just one example of Complaint Power in action: a
TV ad for long-distance phone service hoped to encourage
former residents of rural areas who still had relatives living
there to "phone home." The commercial showed a wheatfield
buzzing with mosquitoes. The voice-over said: "You may
not want to travel there, but you can at least phone. Save
25 percent on long-distance calls." But some people who saw
the ad felt insulted by it. They thought the commercial was
suggesting that these areas were unappealing places to live or
visit. As a result of four complaints, the phone company
cancelled the commercial.

Can you imagine how powerful those people felt?

Often people are surprised to learn that a company will cancel an ad in response to just a few complaints from a handful of people. However, advertisers recognize that for every person who picks up the phone or writes a letter to complain, there are probably hundreds more who are also offended. Smart advertisers often decide to pull the ad that caused concern right away rather than risk angering other potential customers.

Getting Companies To Listen Up

Some complainers are more effective than others. You may have noticed this in life generally: two people can have exactly the same problem with the way something is being done. They can both complain about the problem, but sometimes one person gets the brush-off while the other one gets an apology or a refund.

It often comes down to that old expression, "You can catch more flies with honey than vinegar." As your parents and teachers have probably told you, being polite pays off. Using the sweet approach (honey) is usually more effective than using the sour approach (vinegar).

Here's how it works. Say you hear an ad for a new soda pop on the radio. In trying to be humorous, the ad makes fun of a person with a lisp. You think the ad is mean-spirited and unfair; that it encourages kids to pick on someone who's different. Instead of just concentrating on your own anger, you have to approach the advertiser in a way that ensures the company will take you seriously. In the letter that you write to the radio station and to the soda company, you'll want to point out that:

1 You listen to and like the radio station. This tells the station that you are part of their regular audience, and reminds them that they rely on your attention in order to attract advertisers.

2 You drink pop. This tells the advertiser that you are exactly the kind of person they're trying to persuade to try the new soda.

3 You are offended by the commercial. Here you'll want to explain what you don't like about the ad in a calm and clear manner. The more polite and reasonable you sound, the more likely they are to pay attention to your feedback.

4 You won't buy the soda as long as they air this ad. You're exercising your "Consumer Power" in a way that tells them the ad is backfiring!

5 You'll consider boycotting the radio station if the ad continues, which means you won't hear any of their other customers' ads, either!

6 You're planning to encourage friends and family to follow your lead. This shows that you can gather together some "Companion Power," too.

7 You'd like a written response from both the radio station and the advertiser demonstrating that they understand your concerns, and telling you how they're going to act. This makes it more difficult for them to ignore your letter. And if they have to go to the trouble of writing a response, they'll have to either figure out a way to defend their ad, or make a commitment to pulling it off the air.

Finally, when you sign the letter, you might also consider telling the station and company how old you are. Because not very many kids write to companies, this will make it easier for your letter to get noticed.

It's always a good idea to send your letter to both the advertiser and to its media "host" — the TV or radio station, magazine or newspaper, billboard company or bus line — that allowed the ad to be seen or heard in the first place. And if you can afford the extra stamps, you might also send copies of your letter to the organization in your country in charge of advertising rules (see the end of this chapter).

DON'T Try This at Home!

Patent medicines that claimed they could cure everything from headaches to stomach ulcers were banned decades ago. And yet some advertisers still make promises that sound pretty unbelievable. If you see an ad that makes a claim you think sounds fishy, you can write to the company asking for proof. Be clear that you're looking for evidence that's been gathered in a scientific way. And make sure you tell them you don't simply want more advertising. Sometimes people making such requests have received a whole whack of promotional brochures — in other words, more claims! — instead of actual proof.

Advertising Impact: The Big Picture

The impact of advertising is much bigger than whether or not any one message persuades us to buy this product instead of that one. Because we're surrounded by so many sales messages all the time, we end up thinking about "things" and "shopping" more than we would otherwise.

Imagine you're on a camping holiday with your family, far away from TV, radio, billboards, and magazines. Chances are you're too busy swimming or building a fire or putting up the tent to think about new products you just "have to have!" In fact, people who have lived or travelled in foreign countries where there's very little advertising say that it's a big shock when they come back to North America and see how much space ads take up here.

There are all sorts of really important things in life that don't advertise, but because TV commercials and billboards don't deliver messages designed to remind us of how much pleasure we get from the stuff that can't be bought at a shopping mall, we probably spend less time striving for and valuing the things that really translate into more fun or a better world.

> It's not necessary to advertise food to hungry people, fuel to cold people, or houses to the homeless.
> —John Kenneth Galbraith, economist

Junk Mail Unlimited

Have you ever taken stock of just how many flyers, catalogs, coupons, and contest promotions find their way into your household's mailbox every day? One estimate suggests that bulk mail destroys more than 60 million trees a year and creates 4 million tons of waste. In order to avoid contributing to this process, many people are now putting signs on their mailboxes saying "No Junk Mail" or writing the companies that distribute the materials to "just say no."

These days, some people are very concerned about how successful advertising has been in shifting our focus away from making and using what we need and toward buying more and more stuff simply because we can. Environmentalists point out that making, promoting, and buying products and then throwing them away uses up the Earth's resources. They remind us — sometimes in ads of their own — that there's a limited supply of clean air and water, wood, metal, oil, and gas. And they argue that lifestyles which require us to keep buying new things all the time make it harder for the planet to continue to support us.

There Is No "Away"

Have you ever thought about what happens when you toss out an old toy or T-shirt because it's broken or you've outgrown it? When we throw things away, where exactly IS "away"? More and more, people are realizing that although the world seems awfully big, it's actually quite small. And so far, no one's invented an interplanetary disposal service.

Imagine a family has just acquired a DVD player, and now they've decided they might as well trash their VHS video collection, because they've watched them all a million times anyway. Looked at one way, the 15 videocassettes they put out on the curb for the garbage collector are just the tip of the iceberg. Let's dive below the surface for a minute and explore the pyramid of stuff that had to be used up or thrown out even before the videos existed:

1 Extracting Resources: To make the magnetic tape, the plastic case, the paper label, and the cardboard box that constitute each cassette, raw materials had to be mined and trees had to be cut down.

2 Manufacturing Products: To transform the raw resources into tape, plastic, paper, and cardboard, factories (which use lots of energy) had to be activated to pulp wood into

cardboard and paper products and manufacture the plastic and videotape. And guess what? All of these processes created air pollution and contaminated water.

3 Attracting Customers: To promote the videos, advertising campaigns were created, using more paper (for movie posters, magazine ads, and billboards) and more film, video, or audiotape (for TV or radio commercials and movie trailers).

And this mountain of eventual waste was created before anyone bought the videos, and well before someone decided to throw them "away"!

Green Advertising

On the other hand, advertising is also used by people who are trying to *save* the environment. Organizations like Greenpeace, the Sierra Legal Defense Fund, and the World Wildlife Federation have developed billboard, print, and TV campaigns to encourage people to think about the impact their buying behavior has on our air, water, forests, and endangered animals. Ironically, in order to get their message out, these organizations use some of the very same resources they're concerned with saving—energy, water, and trees.

Can you think of an ad campaign that you've seen or heard recently that encourages you NOT to buy, but to engage in activities that will support, as opposed to harm, the environment? Such "green" ad campaigns don't usually have nearly the same profile or exposure as ads for restaurants or fashion stores. Why is that? What kind of an impact do you think green ads can have on people's attitudes and behavior?

Originally, *Adbusters* was just a magazine; now it's a movement, too. Many people who embrace *Adbusters'* criticism of advertising and consumption call themselves "Culture Jammers." They create images of their own and spoof ads to encourage others to question the way in which our promotion-oriented culture affects how we think and behave. For instance, every year at the end of November—at the height of the Christmas shopping season—they promote "Buy Nothing Day." The point is to get people to stop and think about how much stuff we buy that we don't really need.

And They Said It Couldn't Be Done!

In 1976, a British woman named Anita Roddick started a company called The Body Shop. You may know of this store, which sells soap, shampoo, makeup, and other stuff that people put on — well, their bodies! But if you have heard of The Body Shop, it hasn't been through TV or radio ads, or on billboards or bus shelters. Because this store, which has been very successful in dozens of countries, doesn't use traditional advertising.

Many marketing experts claim that a business can't remain successful if it doesn't advertise. They say that it doesn't matter how good a company's products are, if the company doesn't buy time on TV or space in magazines, then no one will buy what it's selling. But The Body Shop has proven those experts wrong. It promotes itself by supporting environmental and social causes, and relies on "invisible" promotional strategies, like public relations, word-of-mouth, and getting its name in the news. The company also believes that the quality of its products and the fact that it does things to try to make the world a better place will encourage people to buy more than advertising would. What do you think of this approach? Do you think it could work for products such as movies and games?

Ad Execs:
The Next Generation

Years from now, a lot of kids who are your age will be working in advertising or related fields. Some of you will have jobs researching, thinking up, writing, shooting, directing, or acting in TV commercials. And some of you will be in the position of making decisions about how to promote your company's product or service to other people. You'll have the opportunity to change what you don't like about advertising by doing things differently. Like The Body Shop and other companies that are following their example, you might even choose NOT to advertise!

Zapped!

A couple of years ago, a TV commercial showed Oreo cookies going into a toaster and popping up as "KoolStuf toaster pastries." But a four-year-old boy who watched the ad tried to repeat the trick at home. When the melted cookies didn't pop out of the toaster, he used a pair of scissors and some metal tongs to try and rescue them. Obviously he didn't know that putting a metal object into a toaster is dangerous. The good news is that his mother intervened before he was hurt, and then she exercised her "Complaint Power." As a result, the ad was changed.

Pass Your Own Test

As the Ghanian proverb — "To the fish, the water is invisible" — reminds us, advertising is an inescapable part of life in North America. We're basically swimming in commercial messages everywhere we go. This means it's really important to be as aware as possible of the kind of "water" surrounding us. Informed swimmers remember to ask themselves:

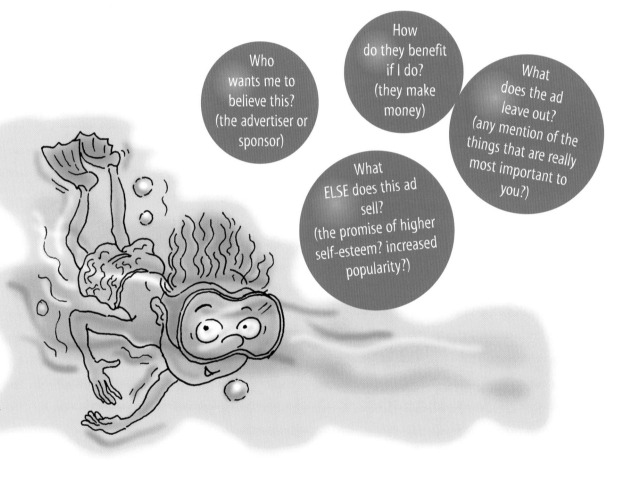

Who wants me to believe this? (the advertiser or sponsor)

How do they benefit if I do? (they make money)

What does the ad leave out? (any mention of the things that are really most important to you?)

What ELSE does this ad sell? (the promise of higher self-esteem? increased popularity?)

Contacting the Ad Enforcers

The following organizations will help you to exercise your Complaint Power.

Government Regulators

UNITED STATES

Federal Trade Commission (FTC)
Bureau of Consumer Protection
600 Pennsylvania Avenue, NW
Washington, DC 20580
website: www.ftc.gov

This government organization enforces US laws — including those relating to advertising practice – that are designed to protect consumers.

CANADA

The Canadian Radio-Television and Telecommunications Commission (CRTC)
Ottawa, Ontario K1A 0N2
website: www.crtc.gc.ca

The CRTC is an independent agency that regulates Canadian broadcasting and telecommunication systems.

Industry Organizations

UNITED STATES

Children's Advertising Review Unit (CARU)
Council of Better Business Bureaus, Inc.
845 Third Avenue
New York, NY 10022
website: www.bbb.org.advertising/childrensMonitor.html

CARU reviews advertising and promotional material directed at children in all media, encouraging advertisers to adhere to the Self-Regulatory Guidelines for Children's Advertising.

CANADA

Advertising Standards Canada (ASC)
Children's Advertising Section
350 Bloor Street East, Suite 402
Toronto, ON M4W 1H5
website: www.adstandards.com

This industry organization handles consumer complaints about Canadian advertising and encourages advertisers to follow the voluntary rules.

Consumer Organizations

UNITED STATES

National Institute for Media and the Family
606 24th Avenue South, Suite 606
Minneapolis, MN 55454
website: www.mediaandthefamily.org

This nonprofit organization is a national resource for research, education, and information about the impact of media on children and families. It works to increase the benefits and reduce the harm of media.

Consumer Reports for Kids Online
101 Truman Avenue
Yonkers, NY 10703
website: www.zillions.org

Zillions started out as a consumer magazine for kids and was
published by Consumer Reports between August 1990 and
September 2000. The magazine is no longer issued, but the
website features many good articles about advertising of interest
to young people.

Center for Media Education & Campaign for Kids' TV
1511 K St. NW, Suite 518
Washington, DC 20005
website: www.cme.org/cme

This national nonprofit organization works to create a quality
electronic media culture for children and youth, their families and
community.

Center for a New American Dream
6930 Carroll Avenue, Suite 900
Takoma Park, MD 20912
website: www.newdream.org

This organization helps Americans to consume responsibly to
protect the environment, enhance quality of life, and promote social
justice. (See the "kids' page" on their website.)

CANADA

Media Awareness Network

1500 Merivale Road, Third Floor
Ottawa, ON K2E 6Z5
website: www.media-awareness.ca

The network's comprehensive website promotes and supports media education in Canadian schools, homes, and communities. It promotes debate about the impact of media in people's lives, encourages critical thinking about media, and features a special "kids corner" for young people.

MediaWatch

417 Wellington Avenue
Toronto, ON M5V 1G5
website: www.mediawatch.ca

This national nonprofit women's organization promotes the improved portrayal and representation of women and girls in the media through research, education, and lobbying.

Adbusters Media Foundation

1243 West 7th Avenue
Vancouver, BC V6H 1B7
email: info@adbusters.org
website: www.adbusters.org

The Adbusters Media Foundation is a global network of artists, activists, writers, pranksters, students, educators, and entrepreneurs. It operates a website and publishes *Adbusters* magazine, which critiques the advertising industry, promotional culture, and consumerism.

NOTES

Chapter 1

Babylonia; ancient Greece; early Rome; "Whatchalack?" Frank Presbrey. *The History and Development of Advertising.* New York: Greenwood Press, 1968, 4–14.

shingle signs. Benjamin D. Singer. *Advertising and Society.* 2nd ed. Toronto: Captus Press, 1994, 17.

street carts; newspaper ads. Stephen Kline. *Out of the Garden.* Toronto: Garamond Press, 1993, 27.

printing press to photography. Courtland L. Bovee. *Contemporary Advertising.* New York: McGraw-Hill, 1994.

patent medicines. Steven Fox. *The Mirror Makers: A History of American Advertising and its Creators.* New York: William Morrow & Co., 1984, 16–18.

Coca-Cola sidebar. Greg Myers. *Adworlds: Brands, Media Audiences.* London: Arnold, 1999. Also at www.colafountain.co.uk.

Kraft Television Theater. The Museum of Broadcast Communications. www.museum.tv/archives/etv/K/htmlK/krafttelevis/krafttelevis.htm.

logos. Ellen Lupton and J. Abbott Miller. *Design Writing Research: Writing on Graphic Design.* New York: Kiosk, 1996, 177.

"advertising chatter"; products sold on radio and TV. W. Leiss, S. Kline, S. Jhally. *Social Communication in Advertising.* Toronto: University of Toronto Press, 1986, 104–12.

Star Wars commercial tie-ins. Mayrav Saar and Olivia Hawkinson. *The Orange County Register.* May 17, 1999. Also Professor of Education, Diane Levin, testifying before the United States Senate Commerce, Science and Transportation Committee Hearing on "Marketing Violence to Children." 4 May 1999, on US Senate site: www.senate.gov/~commerce/hearings/0504lev.pdf (Professor Levin cites *Time Magazine,* 26 April 1999).

Space Jam quote. John Lippman, "Bugs, Michael team up in ultimate commercial movie" in *The Wall Street Journal.* 24 Sept. 1996, B1.

Chapter 2

nag factor. "Kids learn early to nag, study finds." *The Vancouver Sun*. 18 June 2002; www.newdream.org/campaign/kids/facts

back-seat customers. Nancy Day. *Advertising: Information or Manipulation*. Berkely Heights, NJ: Enslow Publishers, 1999.

"Scream Until Dad Stops." Selina S. Guber and Jon Berry. *Marketing To and Through Kids*. New York: McGraw-Hill, 1993.

Mike Searles quote. Ron Harris. "Children who dress for excess: Today's youngsters have become fixated with fashion: The right look isn't enough – it also has to be expensive." *The Los Angeles Times*. 12 Nov. 1989, A1.

Todd Gitlin quote. cited by Mark Crispin Miller in "Divide and Conquer" in *Watching Television*. ed. by Todd Gitlin. New York: Pantheon Books, 1987, 93.

CBS executive quote. C. Ross. "Jordon brings the heart of a marketer to CBS-TV." *Advertising Age*. 3 Feb. 1997, 1, 14.

10,000 commercials. PBS Frontline. "Obesity." 11 Nov. 1998.

research regarding weight gain/loss correlated with TV/video games. www.mediaandthefamily.org (cites many recently published studies).

websites games and contests. Greg Myers. *Adworlds: Brands, Media, Audiences*. London: Arnold, 1999.

"flow state." Media Awareness Network, www. media-awareness.ca/eng/webware/librarians/kids/lkids.htm

Bubble Tape. Leslie Savan. *The Sponsored Life: Ads, TV and American Culture*. Philadelphia: Temple University Press, 1994, 256–57.

Joel Babbitt quote. Gary Ruskin. "Why they whine: How corporations prey on our children." *Mother Magazine*. Nov./Dec. 1999; www.essential.org/alert

12,000 schools, Channel One. "Our relationship with 8.1 million teenagers." *Advertising Age*. 29 June 1998, S27.

volume control of school broadcasts. Naomi Klein. *No Logo: Taking Aim at the Brand Bullies*. Toronto: Vintage Canada, 2000, 89.

research on impact of Channel One. Roy F. Fox. "How Channel One's TV Commercials Affect Students' Thinking, Language, Behavior." Testimony to US Senate Hearing on Channel One. 20 May 1999 (www.commercialalert.org).

cost of classroom time. "Reading, writing . . . and TV commercials." *Enough!* Spring 1999, no. 7, 10.

toothpaste drills and cocoa demonstrations. Stuart Ewen. *Captains of Consciousness*. New York: McGraw-Hill, 1976, 90.

Coke day at high school in Evans, GA. "Coke Day prank fizzles for Pepsi-loving student." Assoc. Press article in various papers, including *Hannibal Courier-Post,* 26 March 1998 and "Looking for Funds in All the Wrong Places" by Alex Molnar, School of Education, University of Wisconsin-Milwaukee on www.asu.edu/educ/epsl/CERU/Documents/cace-00-04.htm (Education Policy Studies Laboratory/Commercialism in Education Research Unit).

third-person effect. W.P. Davidson. "The third-person effect in communication." *Public Opinion Quarterly* 47, 1983, 1–15.

research about preschoolers. R.M. Liebert and J. Sprafkin. *The Early Window*. New York: Pergamon, 1988.

stages of cognition in child development. Anne Sutherland and Beth Thompson. *Kidfluence: Why Kids Today Mean Business*. New York: McGraw-Hill Ryerson, 2001.

alcohol mascots. L. Leiber. "Commercial and Character Slogan Recall by Children Aged 9 to 11 Years." Centre on Alcohol Advertising.

Chapter 3

Nancy Shalek quote. Ron Harris. "Children who dress for excess: today's youngsters have become fixated with fashion: The right look isn't enough – it also has to be expensive." *The Los Angeles Times*. 12 Nov. 1989, A1.

effective words. P.W. Burton. *Which Ad Pulled Best?* Chicago: Crain, 1981. Also in D. Ogilvy. *Ogilvy on Advertising.* New York: Crown, 1983.

headache remedy. D. Bem. *Beliefs, Attitudes, and Human Affairs.* Belmont, CA: Brooks/Cole, 1970.

cost of SuperBowl commercials. www.superbowl.com.

between 20 and 40% of price of product. Shelagh Wallace. *The TV Book: Talking Back to Your TV.* Toronto: Annick Press, 1998, 56.

Grape Nuts cereal celebrity spokesperson. John Emmerling. "Want a celebrity in your ad? OK, but watch your step: A two-question 'test' for celeb campaigns." *Advertising Age.* 1 Nov. 1976.

celebrities in foreign ads. N. Angier. "Who needs this ad most?" *New York Times.* 24 Nov. 1996, E4.

impact of repetition. Anthony Pratkanis and Elliot Aronson. *Age of Propaganda: The Everyday Use and Abuse of Persuasion.* New York: W.H. Freemand & Co., 2001, 181–82.

David Lubards quote. Yumiko Ono. "Marketers seek the 'naked' truth in consumer psyches." *The Wall Street Journal.* 30 May 1997, B1.

food that looks too good to eat. www.zillions.org.

Charles Revson quote. Nancy Day. *Advertising: Information or Manipulation.* Berkely Heights, NJ: Enslow Publishers, 1999, 4. Also in Ronald J. Ebert and Ricky W. Griffin. *Business Essentials.* Upper Saddle River, NJ: Prentice Hall, 2003.

Kathy Bruin, Obsession ad. Kathy Bruin bio. www.about-face.org/aau/bios/kathy.html

Chapter 4

Sony Ericcson Mobile phone/camera, guerrilla marketing. Suzanne Vranica. "Sony Ericsson campaign uses actors to push camera-phone in real life." *The Wall Street Journal.* 31 July 2002.

cool hunt; Reebok. Malcolm Gladwell. "The Coolhunt." *The New Yorker.* 17 March 1997.

E.T./Reese's Pieces. Tom Brook. "Hollywood for sale." BBC News Online. 25 Nov. 2000. http://news.bbc.co.uk/1/hi/entertainment/1039137.stm.

movie product placements. Dale Buss. "A product placement hall of fame." Business Week Online. 22 June 1998. www.businessweek.com/1998/25/b3583062.htm.

Die Another Day placements. "The spy who endorsed me." John Heinzl. *The Globe and Mail.* 22 Nov. 2002, B7.

TV show placements. Peter Vamos. "Branded content: Good for the goose and the gander." *Playback Magazine.* 27 May 2002, 14.

Revlon, *All My Children.* Joe Flint and Emily Nelson. "TV 'plot placement' yields ABC a big advertising buy." *The Wall Street Journal.* 15 March 2002.

subliminal ads. Bob Garfield. "Perspective: 'Subliminal' seduction, and other urban myths." *Advertising Age.* 14 Sept. 2000. www.adage.com/news.cms?newsId=32008.

program-length ads on Saturday morning cartoons. Stephen Kline. *Out of the Garden.* Toronto: Garamond Press, 1993, 218–30. Also in Ellen Seiter. *Sold Separately: Parents and Children in Consumer Culture.* New Brunswich, NJ: Rutgers University Press, 1993, 147–70.

cereal and candy books for toddlers. David D. Kilpatrick. "Snack foods become stars of books for children." *The New York Times.* 22 Sept. 2000, A1.

Neil Young, MTV. J.B. Twitchell. *Adcult USA: The Triumph of Advertising in American Culture.* New York: Columbia University, 1997, 21–22. Also in *Rolling Stone* biography of Neil Young at www.rollingstone.com/artists/bio.asp?oid=229

advertisers' influence on magazine content. Gloria Steinem. "Sex, Lies and Advertising." *MS Magazine.* July/Aug. 1990, 18–28.

KFC ad campaign. Lorne Parton. "Fried and true." *Vancouver Province.* June 1986.

Chapter 5

Scott Paper toilet paper, Listerine scare tactics. Roland Marchand. *Advertising the American Dream: Making Way for Modernity, 1920–1940.* Berkeley: University of California Press, 1985, 102–3 (includes photograph of Listerine ad from *Ladies Home Journal*).

Listerine apology. William E. Francois. *Mass Media Law and Regulation.* 4th ed. New York: John Wiley & Sons, 1986. citing *FTC News Summary,* 18 Dec. 1975.

regulations in European countries. Also in J. Weber. "Selling to kids: At what price?" *Boston Globe.* 18 May 1997, F4.

self-regulatory guidelines for US advertisers. Children's Advertising Review Unit (CARU) of the Council of Better Business Bureaus Inc.; www.caru.org/guidelines.

Canadian regulations. Advertising Standards Canada; www.canad.com.

Tom Waits quote. Michael Jackman. *Crown's Book of Political Quotations.* New York: Crown Publishing, 1982, 1.

department store ad. Sears ad in *The Ottawa Citizen.* 14 Nov. 2002.

It's Everywhere examples: Barbie Pink Month. Dan Chung. "Ash Street in Manchester painted pink for Barbie month." Reuters Toppix News and Sports. 11 Nov. 1997. Columbia Encyclopedia website at www.encyclopedia.com. Pepsi and Coke in Himalayas. "Court to fine companies for painting ads on Himalayas." Agence France-Presse. *The National Post.* 3 Sept. 2002.

Ogden Nash poem. "Song of the Open Road." Copyright © 1933 by Ogden Nash, renewed. Reprinted by permission of Curtis Brown, Ltd.

tobacco logos and athletes. "Tobacco sponsorship." *The Globe and Mail.* 19 Feb. 1997.

"Today's teenager" quote. Advocacy Institute. draft report to the Philip Morris Board of Directors. *Action Alert.* 15 April 1998. As cited in Jean Kilbourne. *Deadly Persuasion: Why Women and Girls Must Fight the Addictive Power of Advertising.* New York: The Free Press, 1999, 186.

Joe Camel. P.M. Fischer, M.P. Schwartz, J.W. Richards Jr., A.O. Goldstein and T.H. Rojas. "Brand logo recognition by children aged 3 to 6 years. *Journal of the American Medical Association.* vol. 245, no. 16, 1667–68. As cited in Kilbourne. *Deadly Persuasion,* 183.

regulators ban Joe Camel. J.M. Broder. "FTC Charges 'Joe Camel' ad illegally takes aim at minors." *The New York Times.* 29 May 1997, A1, B10.

Hollywood movies and the tobacco industry. Smoke Free Movies. a project of Stanton A. Glantz, Professor of Medicine at University of California, San Francisco. http://smokefreemovies.ucsf.edu/problem/fact_fiction.html

Marlboro. www.uchsc.edu/sm/cihl/history_of_cigarette_smoke.htm

celebrities in anti-smoking ads. Centers for Disease Control and Prevention. www.cdc.gov/tobacco/celebs.htm

cows. John Heinzl. "New TV device draws fire for adding more ad noise." *The Globe and Mail.* 1 Nov. 2002.

Chapter 6

John Roberts quote. "Woodstock at 25." editorial. *San Francisco Chronicle.* 14 Aug. 1994, 1.

long-distance phone ad. "BC Tel withdraws ad 'insulting' to Prairies." *The Vancouver Sun.* 17 Aug. 1996.

complaint form adapted from MediaWatch website. www.mediawatch.ca.

John Kenneth Galbraith quote. *American Capitalism: The Concept of Controlling Power.* Boston: Houghton Mifflin, 1956.

junk mail. Los Angeles Department of Public Works. http://dpw.co.la.ca.us/epd/junkmail/index.cfm

The Body Shop. www.bodyshop.com

KoolStuf toaster pastries. Council of Better Business Bureau CARU News. 4 Oct. 2000. www.cluebot.com/articles/00/10/04

INDEX

About the Author

Growing up, Shari Graydon wasn't allowed to watch TV on school nights, so she read a lot of books. She didn't always appreciate it at the time, but now she's convinced it helped her to become a writer.

Since then, Shari has written all kinds of things: brochures and newsletters for big companies and hospitals, chapters for textbooks, columns for newspapers, commentaries for radio, speeches for politicians, and even programs for television. She has taught media literacy at university and is a former president of the non-profit women's group MediaWatch, all of which helped her to write this book. She now lives in Ottawa.